Mastering Composition
for Photographers

Create Images with Impact

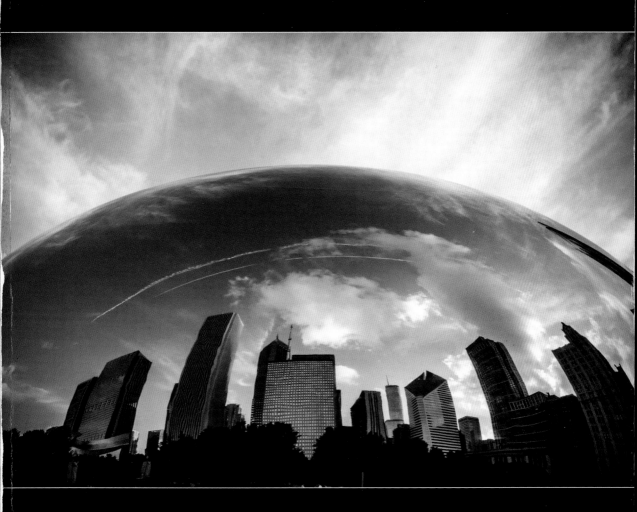

Mark Chen

AMHERST MEDIA, INC. ■ BUFFALO, NY

Acknowledgments

Special thanks to Auliya Flory, I-Ling Chen, Johnny Chang, Olive Chen, Elaine Santos, Marcia Chen, Sharone Goe, Jeff Bradley, Lauren Lohman, and Angie McMonigal. They made the book look good.

Copyright © 2016 by Mark Chen.
All rights reserved.
All photographs by the author unless otherwise noted.

Published by:
Amherst Media, Inc.
P.O. Box 586
Buffalo, N.Y. 14226
Fax: 716-874-4508
www.AmherstMedia.com

Publisher: Craig Alesse
Senior Editor/Production Manager: Michelle Perkins
Editors: Barbara A. Lynch-Johnt, Harvey Goldstein, Beth Alesse
Associate Publisher: Kate Neaverth
Editorial Assistance from: Carey A. Miller, Sally Jarzab, John S. Loder
Business Manager: Adam Richards
Warehouse and Fulfillment Manager: Roger Singo

ISBN-13: 978-1-60895-981-5
Library of Congress Control Number: 2015944884
Printed in the United States of America
10 9 8 7 6 5 4 3 2 1

www.facebook.com/AmherstMediaInc
www.youtube.com/c/AmherstMedia
www.twitter.com/AmherstMedia

Contents

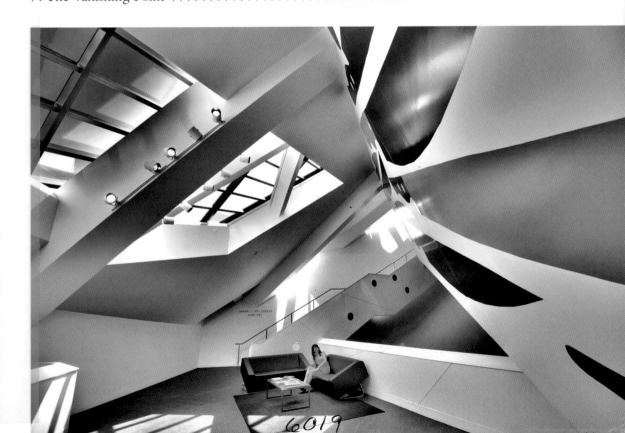

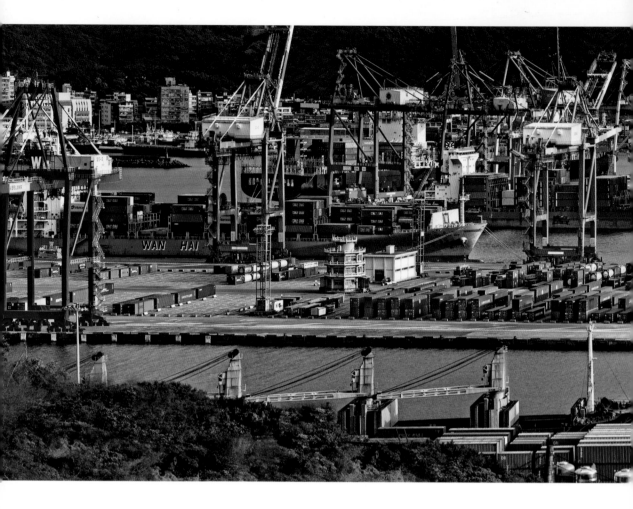

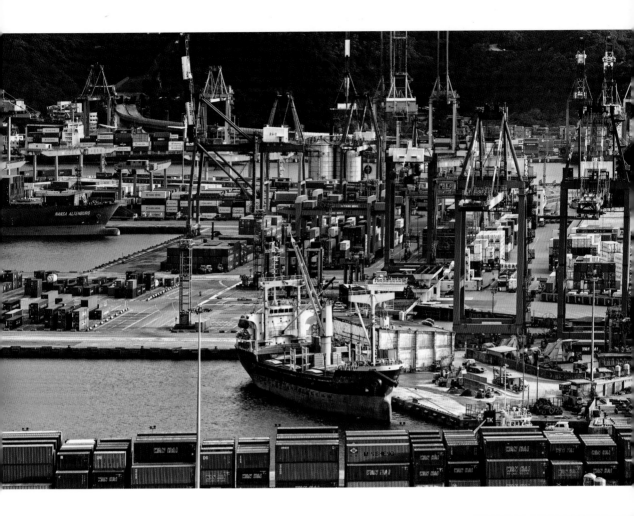

About the Author

Mark Chen is a photographer, a digital media artist, and an activist. While the majority of his work entails creating still images and videos, his talents and work extend to producing media including animation, soundscapes, installations, and performances. Through the narratives in his work, Chen aims to raise awareness on sustainability, climate change, and other environmental and social issues. Digital postproduction is highly integrated into his artistic expression to encompass the essences of fiction, satire, and futurism.

Mr. Chen's exhibition path traverses locally, nationally, and internationally, including the Houston Center for Photography, Fotofest (Houston), the Arc Gallery (San Francisco), and the Artists' Cabin (Taipei, Taiwan). He is currently working on his MFA at the University of Houston, where he receives merit-based scholarships for his education.

In addition to his career as an artist, Mr. Chen is an educator who has taught at University of Houston, Houston Baptist University, and Houston Community College, among other institutions. He is also an avid published author. He has authored seven book titles on photographic art and techniques, all available from Amherst Media.

What Is Composition?

I define composition as "the science of laying out impactful images." It is a "science" because the elements of composition are time-tested theories that are tangible and repeatable. In our efforts to make a photograph that is beautiful, we can rely on time-tested compositional guidelines to develop a pleasing aesthetic. In using compositional tactics, we can make tangible the somewhat mystical qualities and elements that contribute to the fabric of an image that is pleasing to the eye. We can also use those elements to lead the viewer's gaze through the image in a predictable manner.

This book covers discussions on the above-mentioned theories and practices, their usage in photography, and their evolution in the history of photography. It is also a field guide for photographers who want to methodologically incorporate compositional elements into their work in order to raise their art to a new level.

Photographers may gain insight as to how compositional elements are used by the masters, and then, with this understanding, incorporate these strategies and experiment with the same approach.

I define composition as "the science of laying out impactful images."

The Analogical Views

Compositional Elements Are Like Grammar

Grammar gives people who are learning a new language rules to abide by. When these rules are followed, the new speakers can feel secure that those listening to them speak will understand what they are communicating. In much the same way, compositional elements can be used by aspiring photographers to ensure that viewers of their images will clearly understand what they are communicating; their use can also help to coax the anticipated reaction from the viewers.

Compositional Elements Are Condiments

We use condiments to bring out the flavors in our food. Without saffron, paella does not taste like paella. Compositional elements work with contextual elements in a similar way. A great composition enhances the context of a photograph and amplifies its impact.

Compositional Elements Are Keys

Each key unlocks a door. Similarly, each compositional element triggers a certain emotional response from the viewers. This power teams up with the thought-provoking power of an image's contextual elements and forms a unique narrative.

A great composition enhances the context of a photograph and amplifies its impact.

Compositional Elements Are Muscle Memories

Athletes repeat an exercise in order to establish a "muscle memory," a good body form that happens without thinking. Similarly, compositional practices become intuitive. We often say that photographers with this intuition have a "good eye." Teaching you to develop this "good eye" is this book's first and foremost goal.

How to Use This Book

A single photograph often contains many compositional elements. Lines, for example, are present in almost every image. Our interest lies in discerning the dominant compositional elements in the photographs we view and create. Every image has a dominant element and some have several elements that, in combination, build the foundation of a strong image. When you examine the work of master photographers, you will notice strong compositional elements that make these images impressive, impactful, and even iconic. Many books on the topic of composition feature images that seem to have been produced for the sake of demonstration. In this book, we will analyze existing images and "reverse engineer" them. We will consider what it is about each image that makes it work and will answer the question, "Why are these images successful?"

In each of the following chapters, we will take an in-depth look at one compositional element, its definition, and its impact—and in each case, we will view photographic examples that are dominated by this particular compositional element.

In this book, we will analyze existing images and "reverse engineer" them.

Composition Guides

Many of the photographs
included in this book
are accompanied by
composition guides . . .

Many of the photographs included in this book are accompanied by composition guides, which are essentially line drawings of the photograph. These drawings highlight the objects that form a certain compositional element. Take image **2.1** and image **2.2**, for example. The former is the original image and the latter shows where the lines are, where they converge to form the vanishing point, and the way the subject is framed.

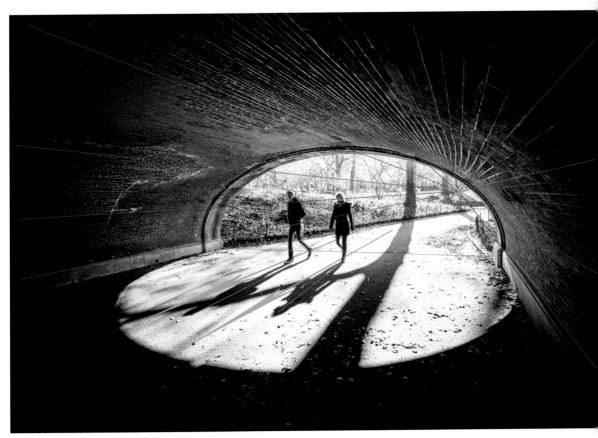

▲ image 2.1
▶ image 2.2

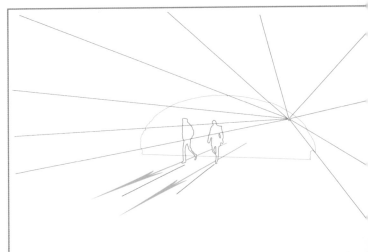

Masterpieces

Masterpieces are iconic images that have earned a rightful place in the history of photography. They are great examples to study: Why do they attract such accolades? What makes them great? While masterworks are an ideal reference point for studying composition, reproducing famous works in a book like this is cost-prohibitive. This does not stop us from learning, however—we are in the age of the Internet! We will be able to study these images and learn from them with the aid of a computer, tablet, or cell phone—and that supremely versatile research tool: Google.

When mention of a masterpiece is made, I've supplied keywords that can be entered into Google Images to call up the referenced artwork. In most cases, the image can be easily located with these keywords; however, when the pieces do not have a known title, the associated composition guide can help you to identify the image. You may simply view the images online and compare them to the composition guide, or, if you are familiar with Photoshop, you may download the masterpieces and, after some simple resizing, overlay them. For download purposes, I recommend that you configure your Google Images search to find large image files so there will be enough resolution for detailed viewing.

I've supplied keywords that can be entered into Google Images to call up the referenced artwork.

Lines

Lines are the most basic compositional element. They manifest in many different forms, and each provokes a different response. They are grooves for the viewer's eyes to glide on; therefore, they are an ideal tool for drawing the viewer's attention. They outline the space, helping viewers to imagine a third dimension on a two-dimensional print or display. Lines also create a sense of movement and add the essence of time to a still photo. The list of the effects that lines create goes on and on.

Horizontal Lines and Horizons

Horizontal lines are the most stabilizing compositional elements. One can argue this sense of stability is rooted in our perception of the ground. Where there is a horizon, there is up and there is down. When our sense of vision conforms to our sense of gravity, there is no concern for vertigo.

The Position of the Horizon

In a landscape, the horizon is not only the baseline for the reference of up and down, it is also the divider of heaven and earth. Where to position the horizon becomes the most basic question to ask before the shutter is clicked.

Horizontal lines are the most stabilizing compositional elements.

Let's examine the effects caused by using various horizon positions.

Analyze a Masterpiece: Ansel Adams

A low horizon leaves a large sky, which creates a strong sense of open space. Earthly terrains and human structures and activities are merely a minor part of the universe. This is not our everyday view of the environment; if it were, more people would have fallen into manholes and cars would be crashing at an alarming rate. We have a very prominent masterpiece that we can use as a reference point: Ansel Adam's *Moonrise Over Hernandez.*

Image **3.1** is the guide to the composition. The horizon is placed at the lower third of the image. Its stabilizing effect is enhanced by many other parallel horizontal lines, including the line of village structures, plant textures, mountains, and clouds. The big sky emphasizes the smallness of Hernandez, AZ, but when we do pay attention to the small village, we see details of the adobe houses and crosses that mark the graves. The principles of repetition and variation will be discussed in another chapter; for now, let's pay attention to the contextual

▶ *Enter Google Images keywords "Ansel Adams Moonrise Hernandez."*

A low horizon leaves a large sky, which creates a strong sense of open space.

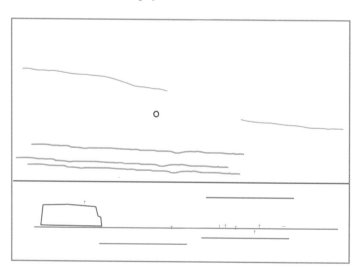

◀ image 3.1

element: the stillness suggested by the adobe houses and the crosses: how many generations living and dead are we looking at in this view? *Moonrise Over Hernandez's* observation is poetic and insightful.

> When the horizon is placed in the middle of the composition, it may strike us as normal, usual, or even plain.

When the horizon is placed in the middle of the composition, it may strike us as normal, usual, or even plain. This is not to say that a centered horizon makes for a boring photo, however, as other compositional elements might dominate and successfully create interest.

A high horizon indicates a downward-looking view. The photographer wants the viewers to concern themselves with what is on earth. If a short focal length lens is used to create a wide field of view, the features on the land would have a strong element of foreground/background comparison.

▶ *Enter Google Images keywords "Edward Burtynsky Oil Fields."*

Analyze a Masterpiece: Edward Burtynsky

Edward Burtynsky, known for his devastatingly beautiful portrayals of environmental horrors, uses high horizons often. Take his *Oil Fields #18*, for example. Image **3.2** is the composition guide. The horizon is nearly pressing

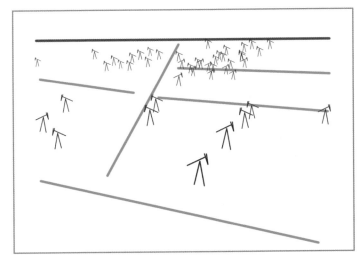

▶ image 3.2

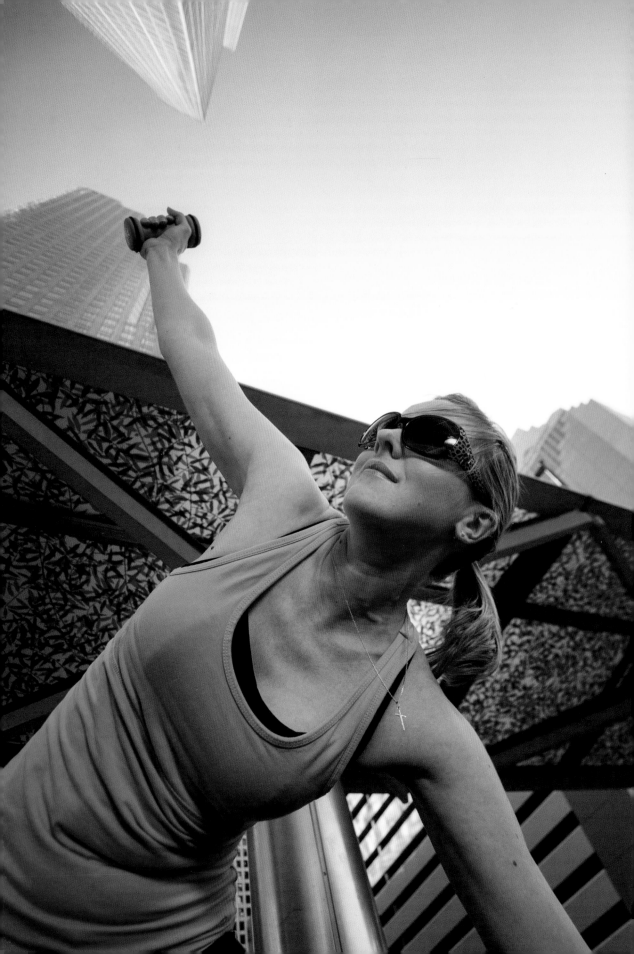

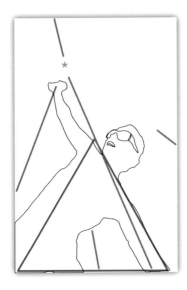

◀ image 3.3
▲ image 3.4

against the upper edge of the frame, leaving a small, hazy sky. Another dominating compositional element is repetition and variation, which is used on the countless pump jacks. Combining repetition with a high horizon, he presented a landscape that is sublime and suffocating at the same time.

Now, let's look at an image that excludes a horizon.

A no-horizon, upward view can be so destabilizing that it makes viewers feel dizzy. Often, other compositional elements have to kick in to stabilize the image. Keep in mind, though, these notions are not meant to be negative. The heightened sense of instability can increase the dynamic feeling in an image.

Image **3.3** is an example of an environmental portrait without a horizon. The absence of a horizon lends a dynamic feel. The lack of stability is made up for by two other elements: first, the vanishing point, marked by the asterisk (*) in image **3.4**. From this definitive point of upwardness, the lines of the buildings and the model's outstretched arms suggest the pull of gravity. Second, the stabilizing triangular form of the model's body adds a sense of weight at the base of the composition. A balancing act is achieved without the help of the horizon.

Vertical Lines

Though vertical lines are not as stabilizing as horizontal lines, they do come in second place in that regard. Vertical lines run parallel to the direction of gravity. When they have an upward direction (which is the case for most vertical lines), they defy gravity and provide an uplifting sense.

> A no-horizon, upward view can be so destabilizing that it makes viewers feel dizzy.

Like many other compositional elements, the effects of vertical lines are tightly knit to the context in which they are used.

Analyze a Masterpiece: Yousuf Karsh

No pose is more dignified than one in which the figure is standing straight and tall. To defy gravity and to stand straight requires strength. However, the human figure is a rather mellowed form: many of the lines it encompasses are hidden, built on its frame of bones. In a photograph, what we perceive is based on our understanding of our fellow humans' bone structure. Take Yousuf Karsh's famous portrait of Winston Churchill, for example. At 5 feet, 6 inches, Churchill was hardly a towering physical presence. But in Karsh's portrait, Churchill's upright stance, coupled with the stabilizing triangular composition, timelessly portrayed him as a strong individual whom the whole world relied on. Image **3.5** illustrates the composition.

► *Enter Google Images keywords "Yousuf Karsh Churchill."*

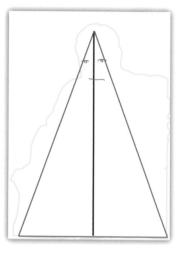

▲ image 3.5

Vertical Lines in Architecture

Gravity-defying vertical lines are also abundant in skyscrapers. The upward thrust of these giants is formally and symbolically interesting. A photograph is most effective in impressing the viewer when its formal elements and contextual elements unite in a composition. Image **3.6** shows part of the Chicago skyline as viewed from Lake Michigan. This composition, with its many vertical lines reinforced with a portrait orientation, provides an excellent example of such unity. Image **3.7** illustrates the vertical lines in this composition. The variations in the heights of these lines constitutes another compositional element—repetition and variation.

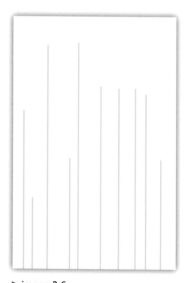

► image 3.6
▲ image 3.7

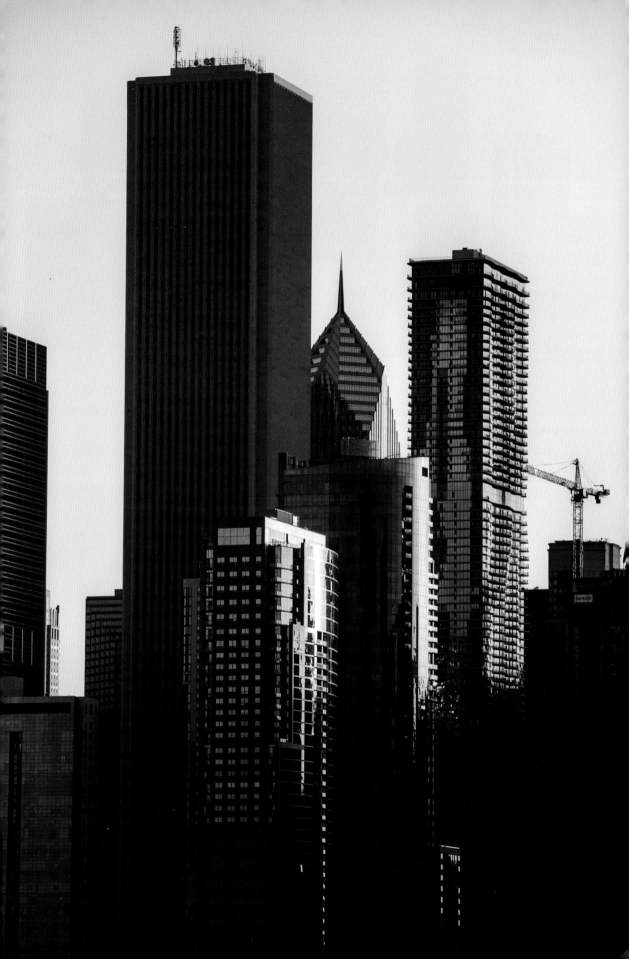

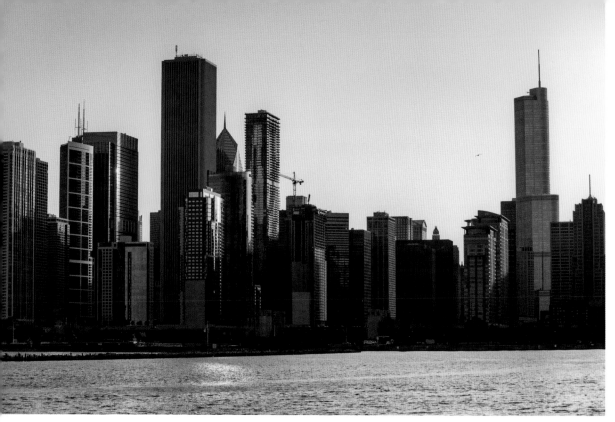

▲ image 3.8

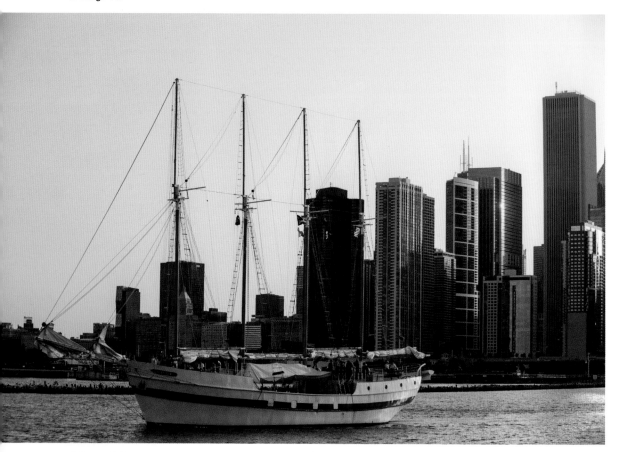

▲ image 3.9

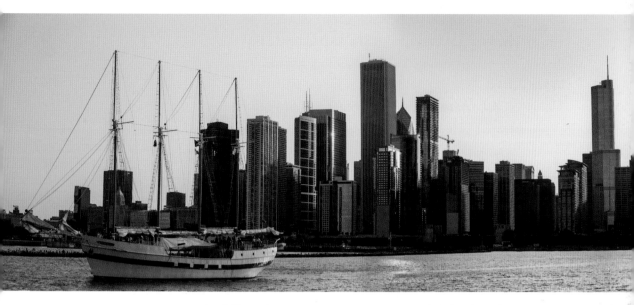

▲ image 3.10

When the same scenery is presented in landscape orientation, the impact of the vertical lines is weakened, as you can see in image **3.8**. In image **3.9**, reenforcement from the tall ship with its sharp vertical line helped to strengthen the composition. Finally, stitching image 3.8 and image 3.9 together gave birth to image **3.10**. Interestingly, the effect of its vertical lines feels stronger than it does in image 3.8 or image 3.9, even though the panoramic crop that was used further expands the view in the direction of horizon. One possible explanation is the sheer power of repetition.

Vertical Lines in Nature

Vertical lines are plentiful in the botanical kingdom amongst the trees. Geologically, it is a rarity. As far as I have witnessed, there is no creation of Mother Nature with more vertical lines than Bryce Canyon, where hoodoo formations provide many implied vertical lines with rich details. Image **3.11** (page 20) shows one such formation. To showcase the vertical line composition with more gusto, I stitched together images to create a vertical panorama, which you will see in image **3.12**. This crop is unusual for photography but is rather popular in Chinese

> When the same scenery is presented in landscape orientation, the impact of the vertical lines is weakened.

watercolor, in which landscapes with strong elements of foreground/background composition are featured. This Bryce Canyon image can certainly claim that lineage. Image **3.13** is a fine example of such Chinese tradition. This piece, *Mt. Huang,* is by Shino-Nan Chen, my mother.

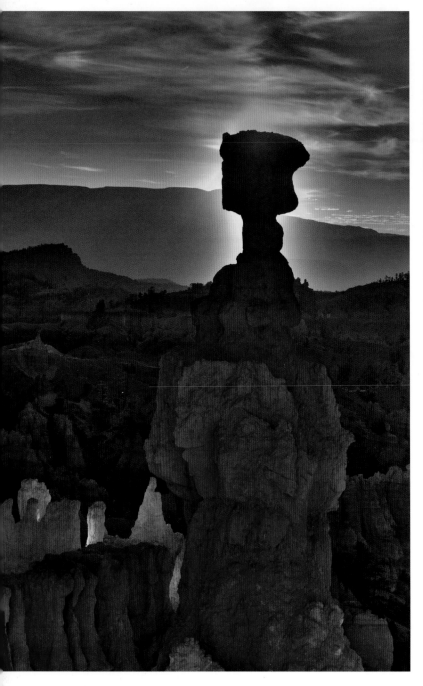

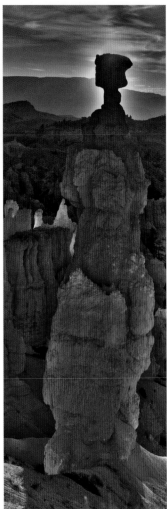

◄ image 3.11
▲ image 3.12

► image 3.13

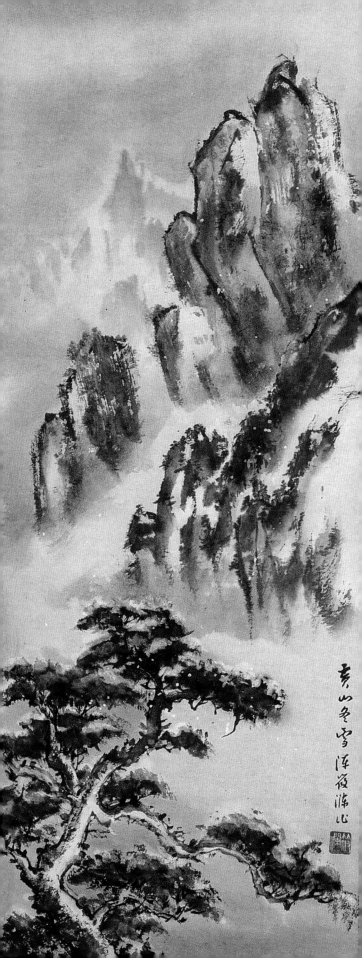

Leading Lines

Leading lines grab the viewer's attention and lead the eye from one point to another. Leading lines may be considered as a formal element in their own right, but it is worth noting that they are also used to organize the composition.

Analyze a Masterpiece: Edward Weston

Edward Weston was a master of forms. He saw harmonies among green peppers, shells, and nudes, and used leading lines in some of his compositions. Take *Epilogue,* for example, and use image **3.14** as the composition guide. The red line, the shadow of a building structure, is obviously the leading line. The leading line also divides highlight and shadow areas that occupy two contiguous areas of the image. The human figure, specifically her facial features, are the sharpest details in the image, yet she is connected to the other dominating forms, diagonally positioned away from her by the leading line. The leading line acts as a docent, guiding and informing the viewers.

Physical Lines and Imaginary Lines

Physical lines are not the only type of lines a photographer can utilize in an image. Lines in a photo can also be imagined. Sometimes they are extensions of physical lines. When the faces of human or animals are present in an image, their lines of vision often form imaginary lines. Reconsider Edward Weston's *Epilogue,* now in image **3.15,** with an additional marking of the imaginary line of the subject's line of vision. In this masterpiece, the imaginary line further strengthens the connection between the human figure and the potted plant—this time, through the three-dimensional space! Observe how the eyes point to the direction of the light source where the plant is placed: we can imagine that she is looking right at it. The

► *Google Images keywords "Edward Weston Epilogue."*

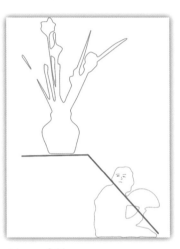

▲ image 3.14

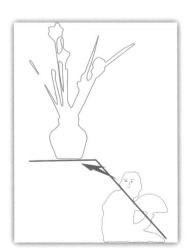

▲ image 3.15

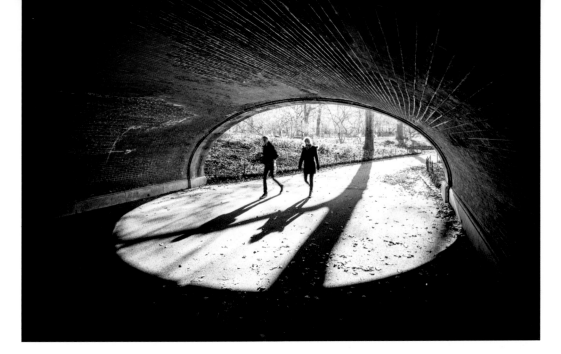

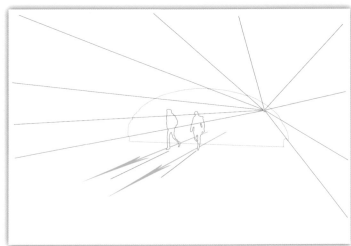

ingenious composition is simple, effective, imaginative, and elegant. It has what it takes to be a masterpiece.

Radiating Lines

When there are multiple lines emitting from one point, they are radiating lines. Radiating lines can be highly dynamic and create a strong spatial sense. The spatial sense is particularly prominent when the radiating lines originate from the vanishing point. Image **3.16** shows one of the dozens of bridge underpasses that dot Central Park in Manhattan. They seem to me to be passages that connect space and time; hence I entitled this *Wormhole of Central Park*. To convey this science-fiction narrative, I used the radiating lines with a vanishing point composition. Refer to image **3.17** for the compositional analysis. These radiating lines are hybrids of physical and imaginary lines (marked

in green). As the physical lines in the tunnel progress toward the end of the tunnel, they continue in our mind and eventually converge at the vanishing point (this is marked by an orange asterisk [*]). This element is then strengthened by the direction of the sunlight: the shadows of the tree and the two "time travelers" conform to the direction of the radiation. On top of all these perfect coordinations, the direction of the movement of the two time travelers (marked with orange arrows), enhanced by motion blur, also form imaginary lines which join the radiating bunch. The compositional elements in this image are tightly knit and support a unique aesthetic and narrative.

Parallel Lines

Parallel lines in a composition create a strong impression, and they can be detected by the viewer without much effort. Recall image 3.1, our earlier discussion on Ansel Adams' *Moonrise over Hernandez*. This iconic image's horizon is prominent in the composition, but the master did not stop there. He enhanced the horizon by adding parallel lines to it: the lines of the rustic buildings, the texture of the plants, and the clouds. These parallel lines underscore the horizon and emphasize its prominence.

Recall the parallel vertical lines in image 3.6. The repetition emphasizes the might of a great city. Consider the original World Trade Center. The twin towers were two parallel, minimalistic structures thrusting vertically into the sky. There is no better way to portray strength.

In the world of art, a formal element can be purposely used to contradict the context. This is particularly true in the work of the postmodernists, whose aesthetic ideals ran counter to the approaches used by pictorialists and modernists. Readers are encouraged to research the

In the world of art, a formal element can be purposely used to contradict the context.

postmodern movement, which started in the mid 20th century.

► *Enter Google Images keywords "William Eggleston For Now" and look for an image with two rifles and the legs of a woman in jeans.*

Analyze a Masterpiece: William Eggleston

Let's look at an image from William Eggleston, a leading figure in the postmodernist movement, as an example. The image we will study is from the book *For Now* (Twin Palms Publishers; 3rd edition, 2010). Image **3.18** shows the outlines of the image.

▲ image 3.18

If any reader is unfamiliar with postmodern photography, this example could cause some degree of puzzlement. Postmodernism can be viewed as a reactionary movement opposed to "beautiful art photos." Practitioners turned their lenses to the obscure or banal for inspiration, but the fact is, the images they created are by no means banal. In Eggleston's image, the parallel lines between the rifles and the legs create an interesting equilibrium, yet the two subjects are so completely juxtaposed that the image becomes contradictory and enigmatic. Why are those lethal weapons present during such a leisurely moment, in which the woman sits relaxed and holding a (barely visible) drink of some sort? The parallel lines instill harmony between the weapons and the woman, yet the context is loaded with inexplicable uneasiness. Although the postmodernists tout their revolutionary views on aesthetics, there are still traces of compositional elements in their images. Compositional elements are so fundamental to art; it is hard to toss them out of the window.

Open and Closed Compositions

A n open composition leaves viewers with the impression that the image displays only a part of a larger picture—that there is more to the story than what is shown. A closed composition is a complete collection. Its stories are told within the frame; the image piques little curiosity about what might exist beyond the confines of the photograph.

Analyze a Masterpiece: Michaelangelo

An open/closed composition is strong both formally and contextually. It also has a long historic aspect, which originated way before the era of photography. Our first example is a Renaissance painting *The Last Supper*, arguably Michelangelo's most famous piece.

Image **4.1** is the compositional analysis of *The Last Supper*. Feel free to download the image result from your Google Images search and then, in Photoshop, apply the image as an overlay. Some resizing may be required.

Observe the arrangement of the human figures, the placement of the table, and the perspective of the interior

▶ *Enter Google Images keywords "Michelangelo Last Supper."*

▲ image 4.1

space. Pay special attention to the details of the human figures: Jesus is in the center and the disciples flank him on both sides. The lines of sight of the disciples form many imaginary lines, all focused on Jesus. Finally, the two disciples at the ends of the table face inward, with their bodies bent toward the middle, forming two "brackets." On top of these, the walls' receding parallel lines converge to a vanishing point, right on Jesus' face and the walls themselves form a framing. All these elements serve one purpose: they guide the viewer's attention to the central figure, Jesus. This is a closed composition. *The Last Supper* is a universe in its own right. It leaves viewers without any curiosity about what exists beyond the frame of the painting.

► *Google Images keywords "Edgar Degas The Rehearsal 1874."*

Analyze a Masterpiece: Edward Degas

While closed compositions were common during the Renaissance, painters in the 19th century broke that mold frequently. Many of Edgar Degas' paintings of dancers employed open compositions. Take *The Rehearsal, 1874,* for example, and refer to image **4.2** for a compositional analysis.

▲ image 4.2

Observe how the subjects in the painting are partially left out of the frame. On the left, we have a limited view of the spiral staircase; on the top of the stairs, a dancer's feet seem to be shuffling down into the painting. The group of the dancers at the top-left extends all the way out of the left edge. Most prominently, the dancers in the foreground to the lower-right corner have lots of interesting actions going on: the sitting one looks on with a smile, while the ballet mistress fixes the tutu of a dancer who was cut right on the face. This presentation would have been unfathomable for Michelangelo.

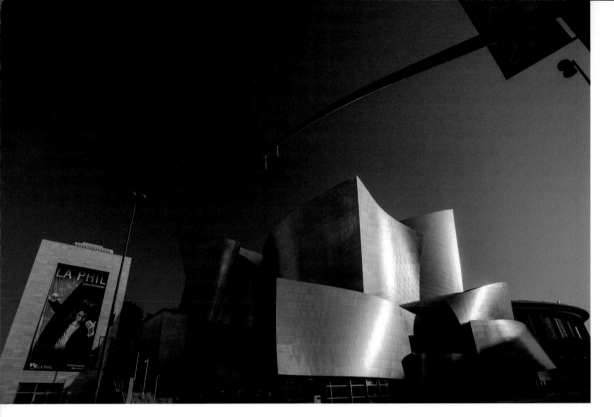

▲ image 4.3

Degas carefully left out parts of the subjects to stir up his viewers' imagination. He hinted, "There is a lot more in this studio." *The Rehearsal, 1874* is a quintessential example of open composition.

Now, let's turn our attention to three images I made from Frank Ghery's masterpiece: Disney Hall, Los Angeles. Its curved and fragmented structures and metallic surface make it a fascinating subject for architectural photography. Walking around it, there seem to be endless possibilities for portraying it.

Images **4.3**, **4.4**, and **4.5** are interesting to compare. They are on three different points in the spectrum of open/ closed compositions. Image 4.3 is fully closed: the whole building is in sight, and the banner on the left of the structure and a background building on the right bracket it. The traffic light and the sky also support the closed composition. Image 4.4 has a half-open and half-closed

Let's turn our attention to three images I made from Frank Ghery's masterpiece: Disney Hall, Los Angeles.

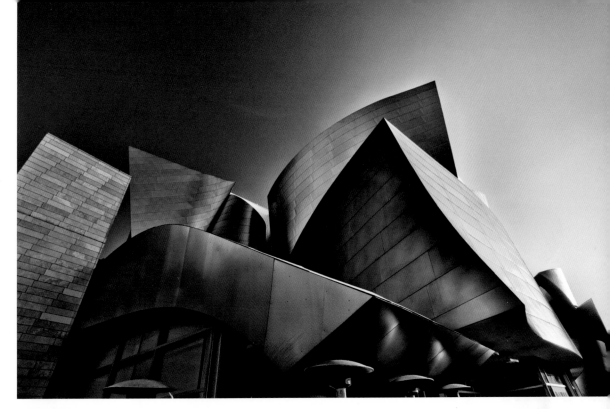

▲ image 4.4

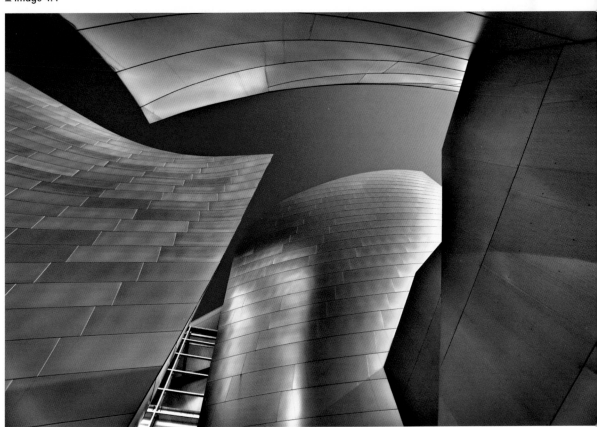

▲ image 4.5

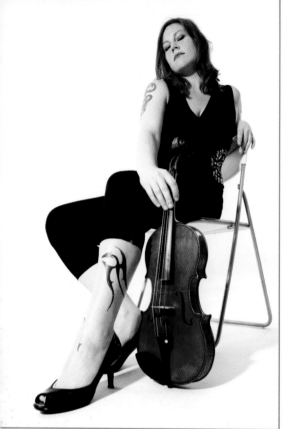

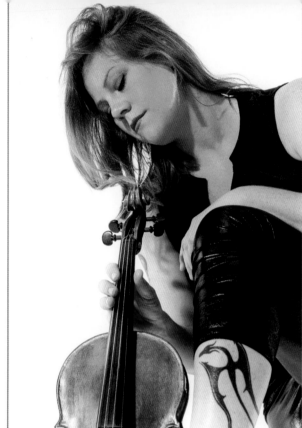

▲ image 4.6

▲ image 4.7

composition. Although the structure seems to be self-contained, many features are left out.

Image **4.5** is an open composition: with an upward angle of view, only the top-most portions of the structures are visible. In the image, there is no horizon, but there is a prominent negative space and a vanishing point. These elements make for a highly dynamic portrayal of otherworldly architecture.

Open/closed composition can be applied to portraiture too. Image **4.6** and image **4.7** are examples. These two portraits were made to portray this musician's eccentric personality. They have an open and a closed composition, respectively. Which portrait tells a more complete story about the subject?

Which portrait tells a more complete story about the subject?

Now, let me introduce a photograph made by my colleague, Auliya Flory, who is an expert on the female form. Flory's work centers on a narrative of female social identity. Female body forms are often used to provide the context. Image **4.8** is an open composition. The limbs of a woman, twisted in an unnatural way, form intersecting lines that take our eyes on a roller coaster ride (see image **4.9**). As the work has an open composition, lots of

The limbs of a woman, twisted in an unnatural way, form intersecting lines that take our eyes on a roller coaster ride.

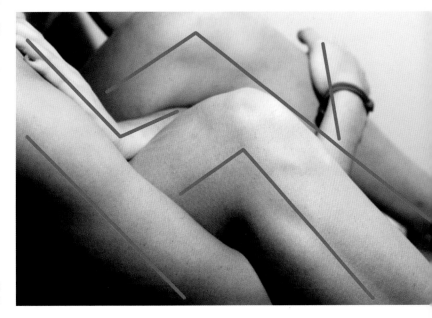

▼ image 4.8
► image 4.9

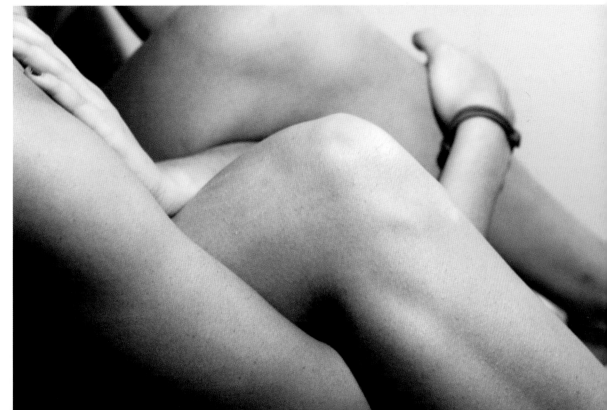

information is left out. There is a great deal of room for imagination.

Analyze a Masterpiece: Robert Frank

Finally, we shall look at how the masters used open/closed compositions in their images. Robert Frank is a renowned street photographer. *The Americans* (Steidl, 2008) is a collection of photographs that portray post-World War II Americans in all stratas of society. He was also a pioneer in commentating on the issue of race in this country. Let's first look at his image, *Parade—Hoboken, New Jersey*. Refer to image **4.10** for the compositional analysis. The half-shown American flag and windows pushed beyond the edges of the image set the stage with an open composition. The most masterful touch is the figures in the windows. They are either half hidden in shadow or their faces are obscured by the flag. What we are looking at here is an open composition within an open composition, in which Robert Frank instilled a strong sense of mystery. What is the true identify of these people? What are their gut feelings for the parade, supposedly taking place on the street outside of their window? Does the half-shown flag suggest that patriotism is under scrutiny?

Robert Frank sure raised lots of questions. No wonder his work was greeted with controversy. Although his prominent position in the history of photography is well established today, he was ahead of his time.

► *Enter Google Images keywords "Robert Frank Parade Hoboken New Jersey."*

What we are looking at here is an open composition within an open composition.

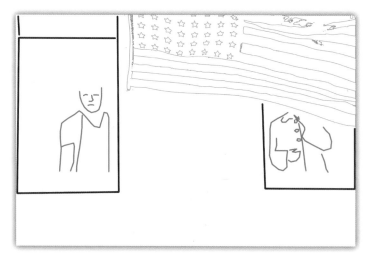

◄ image 4.10

Foreground/Background and Depth of Field

We live in a three-dimensional world. Our visual experience with the environment naturally provides a strong spatial perception. In a photograph, the three-dimensional world is represented on a two-dimensional medium. Does this flattened representation diminish the sense of the third dimension?

As it turns out, the reduction of the physical depth in a two-dimensional medium can trigger our imagination and make us mentally add the missing dimension back. Looking at a photograph, we can easily traverse the three-dimensional space it portrays in our mind. This experience is heightened when the element of foreground/background is in play.

Image **5.1** (page 34) shows a cemetery in Queens, New York. The foreground is crowded with headstones. In the background, a steel bridge is carrying commuting-hour traffic. The foreground and background are bordered by a distinctive horizontal divide. This divide is underscored by yet another compositional element: repetition and variation. The pattern of the headstones—repetitive shapes of crosses and columns—are unified by the texture of

> Looking at a photograph, we can easily traverse the three-dimensional space it portrays in our mind.

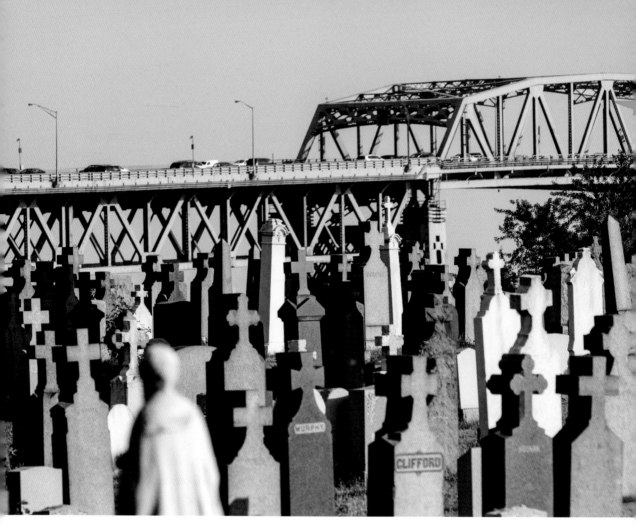

the stone. The repetition in the bridge is formed by the crisscrossing steel beams, dotted with the cars.

▲ image 5.1

The magic of this image is the harmony between the form and context. The formal division, as analyzed above, perfectly coincides with the division between the dead and the living. For the former, it is quiet and still; for the latter, it is loud and busy.

Let's examine the foreground/background compositional elements in some masterpieces.

The magic of this image is the harmony between the form and context.

▶ Enter Google Images keywords "Ansel Adams Farm Worker Williamson."

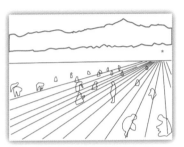

▲ image 5.2

Analyze a Masterpiece: Ansel Adams

Ansel Adams' *Farm Workers at Mt. Williamson* is such an example. Refer to image **5.2** for the composition guide. This is an image from his series of the Manzanar Relocation Center where American Japanese were interned during the Second World War. The red horizontal line divides the foreground and background. In the foreground, the focus is on the laborious farm work, which altered the landscape into something unnatural: radiating lines of the field dotted with farmers hard at work. If you extend these receding lines, you will see that they converge at a vanishing point, which provides a sense of vastness. This image is another case of harmonization of form and context, as the foreground's and background's meanings become perfectly synced with the composition.

▶ Enter Google Images keywords "William Eggleston."

Analyze a Masterpiece: William Eggleston

William Eggleston might not be as well-known as Ansel Adams, but he is rcredited with two accolades in the history of photography. He is considered the father of color photography and is one of the initiators of the postmodern movement in photography. Postmodernists turn their lenses away from grandiose landscapes, dramatic street scenes, and intriguing still lifes. Instead, they focus their efforts on capturing images of the banal.

▲ image 5.3

Let's examine two images by William Eggleston. His pieces are mostly untitled; therefore, you will need a bit of visual search following the Google Images search. Our first example is an image taken in a diner. The composition guide for the photograph, image **5.3**, might help you locate the image. In the center of the image, the back of a woman with a peculiar hairdo dominates. She and her companion, facing her and with his face blocked by her head, each hold a cigarette. The woman's hairdo is the

apparent point of interest: its unusual twists and knots, its shape and the pins, are sharply presented in the very center of the image and incite curiosity in the viewer. Both she and her companion, clearly a man, are both unidentifiable because their faces are hidden. The cigarettes they hold and the hands that hold them form a strong connection between the two individuals, both formally and contextually.

Foreground/background compositions are often used in conjunction with a shallow depth of field. In the examples of Ansel Adams' *Farm Workers at Mt. Williamson*, the long focusing distances resulted in a very wide depth of field. The shallow depth of field of this scene at a diner, though, strongly enhances the foreground/background composition. The narrow range of focus makes the woman's hairdo the sharpest component and mutes the man facing her, the object on the table, and the texture of the brick wall. Those elements set the stage for the story, but they don't steal the limelight.

Foreground/background compositions are often used in conjunction with a shallow depth of field.

The composition of this piece made it an enigma: What does the woman look like? What does the man look like? What kind of relationship do they have? Why are they both smoking? If Eggleston moved a foot to the right and photographed the scene as most of us would have done, he would not have ignited a burning curiosity in us.

William Eggleston's best-known image is *Memphis* (yes, that is its title, but it is better known as *Tricycle*). Refer to image **5.4** to review its composition guide.

▶ *Enter Google Images keywords "William Eggleston Tricycle."*

Here is a quote from Eggleston himself: "Sometimes I like the idea of making a picture that does not look like a human picture. Humans make pictures which tend to be about five feet above the ground looking out horizontally.

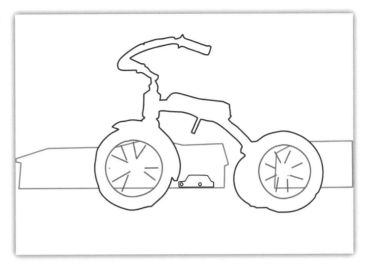

I like very fast-flying insects moving all over, and I wonder what their view is from moment to moment. I have made a few pictures which show that physical viewpoint. . . . The tricycle is similar. It is an insect's view or it could be a child's view."

This sounds like a half-hearted, casual statement by the master, yet it is the spirit of postmodernism in a nutshell. For us, this statement is a valuable lesson of composition: see the world in an unusual way; don't make it an everyday view. Who needs an everyday view when one can do it himself? A photographer should provide a fresh new look that no one has seen before.

Compositionally, this simple play of foreground/ background reversed our understanding of scale. The enormous tricycle overwhelms the house and the car in the background, defying common sense. This formal element has a subtle connection to the symbolic aspect of the image as revealed in Eggleston's quote: in a child's view, the tricycle might be grander than the house. Eggleston must be well in touch with the little kid in him.

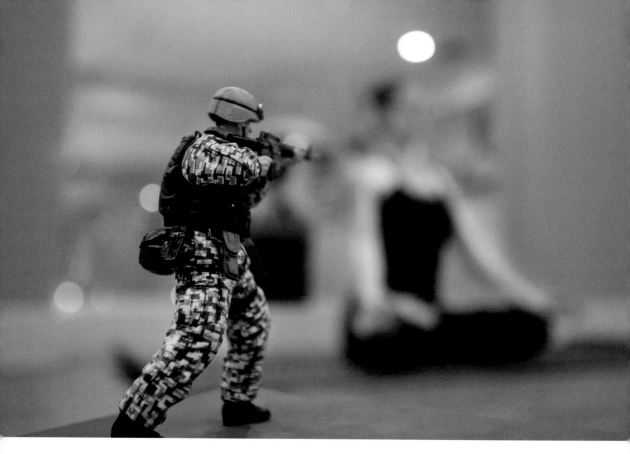

Image **5.5** is another example in which foreground/ background composition is used in conjunction with a shallow depth of field. This image, which symbolizes intrusion of privacy and brutality against peaceful movements, has a very shallow depth of field; the whole of the soldier is barely in focus. To achieve the effect, I used the largest aperture setting on my super wide angle zoom lens. The factors that govern depth of field are covered in detail in my book *Mastering Exposure: How Great Photography Begins* (Amherst Media, 2015).

The focus on the foreground and use of shallow depth of field seem to emphasize the soldier. However, the form of the yoga practitioner is iconic and clearly identifies itself despite the blurry veil. Formally speaking, the soft and blurry yogi counteracts with the harsh and sharp soldier, while their contextual interactions are in agreement.

▲ image 5.5

Formally speaking, the soft and blurry yogi counteracts with the harsh and sharp soldier.

Image **5.6** is my take on the Statue of Liberty from the perspective of a boat crowd. It would have been a sight when migrants shuffled into the United States of America. But this port of entry is no longer the gate of migration, and this boat does not carry immigrants. It now carries tourists, who look at the Lady with a very different mind-set. Excited, perhaps; elated, not likely.

This image has rather radical usage of several compositional elements. The shallow depth of field makes the Statue of Liberty the only object in focus; the crowd is very blurry. This establishes the Lady's position as the dominator. She is positioned at the very center of the image; this further attracts the eye. The depth of field works with the foreground/background composition as a means to achieve selective focus. The collective effects of these compositional elements achieve a great feat: a tiny object becomes a centerpiece that grabs all of the viewer's attention.

> The depth of field works with the foreground/background composition as a means to achieve selective focus.

▼ image 5.6

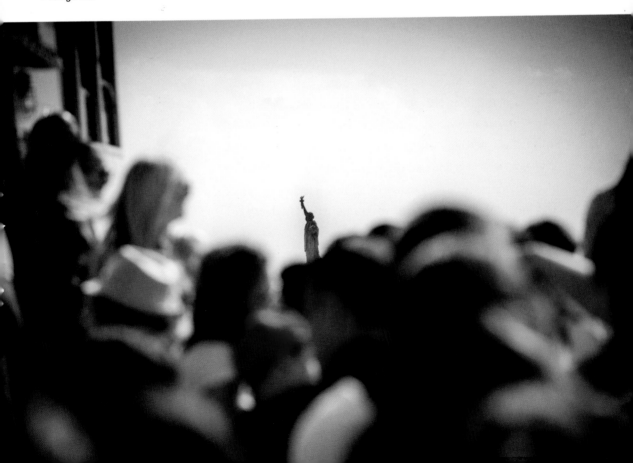

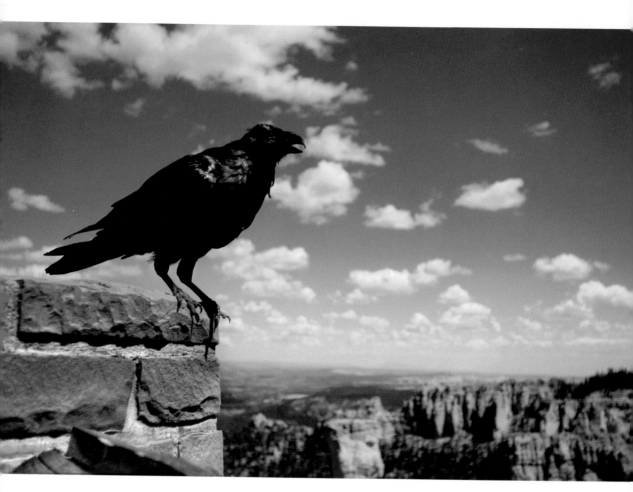

▲ image 5.7

Switching from metropolitan to nature and swapping the prominence of foreground and background, we have image **5.7**, taken during a brief encounter with a crow at Bryce Canyon. The close-up shot of the handsome bird gives it a scale that allows it to dominate the composition. In this case, getting close is good, as Robert Capa advised. The closeness also allowed the texture of the crow's pitch-black feathers to show. On top of all this, placing the crow at a rule of thirds point really makes the bird king of his domain, which is depicted in the background.

Placing the crow at a rule of thirds point really makes the bird king of his domain.

▶ Enter Google Images keywords
"Robert Capa Face Surf."

Analyze a Masterpiece: Ansel Adams

Robert Capa's iconic image of the Normandy Invasion, *The Face in the Surf* is one of a handful of surviving images shot during the first wave of the landing. Capa witnessed soldiers being shot, blown to pieces, and set on fire right around him. He came to the rescue of a wounded soldier, Hutson Riley. In the process, he captured this image. Both individuals and this image survived the invasion to tell the story.

Image **5.8** is the composition guide for this image. A strong narrative is carried by this foreground/background composition, in which the only sharp aspect is the face of Private Riley in the foreground. In the background, which appears blurry due to a combination of shallow depth of field and motion, there are barely discernible shapes of anti-tank hedgehogs, floating objects, and the surf. The blurriness did not diminish the intensity of this battleground—it actually raised the viewers' uneasiness about it. What are we looking at? Is that a soldier in the background? Are we seeing death?

> A strong narrative is carried by this foreground/background composition, in which the only sharp aspect is the face . . .

▲ image 5.8

Dominators

An image is like a stage for a performance—a ballet, drama, or concert. A ballet, for example, can have scenes with many dancers in the corps de ballet, or it can have soloists dancing with that group, or a spacious stage with just a single soloist.

In these different types of scenes, the audiences' attention is directed by carefully thought out choreography. When a soloist is dancing with a large number of dancers, the expectation is that the audience's focus will remain on the soloists most of the time and sporadically shift to the overall presentation of the supporting dancers. This is achieved by placement, lighting, dance movement, etc. In this scenario, the soloist is the dominator—the dominant element in the scene.

A photograph with lots of subjects often needs the same compositional consideration. This is particularly useful for street photography, which often encompasses a rather chaotic setup that is out of the photographer's control.

In this scenario, the soloist is the dominator – the dominant element in the scene.

► *Enter Google Images keyword "Lee Friedlander America by Car."*

The photographer used a Hasselblad with a wide angle lens, so the views are inherently chaotic . . .

Analyze a Masterpiece: Lee Friedlander

Let's examine a couple of examples by a master of street photography, Lee Friedlander, whose vision is one of a kind and never fails to surprise and delight.

Friedlander's book *America by Car* (D.A.P./Fraenkel, 2010) presents a series of street scenes, always shot from the interior of a car. The photographer used a Hasselblad with a wide angle lens, so the views are inherently chaotic, with so many subjects inside and outside the car. Let's look at the book's cover photo to see how Friedlander used the dominator concept as a compositional element to rein in the chaos. Image **6.1** is the composition guide for the photo.

The dominator is, by all means, the car resting on top of a post. Formally, it occupies a prominent spot framed by the driver's-side window, though not entirely at a rule of thirds

► image 6.1

point, a compositional element Friedlander often chooses not to comply with. The avoidance of this traditional composition gives his work a flare of modernism. Contextually, this image presents a rarity that one cannot miss: how often do we see a car in the air?

Like watching a soloist and the corps de ballet, our attention does not fall solely on the dominator. This image is laden with fun details. The mirror shows a scene of a typical cross-country road trip, with mountains, a car, and roadside features. The interior serves the purpose of framing and also sets the context.

Another well-known piece by Friedlander, *Shadow—New York City* is an example from his many self-portraits. For a compositional guide, please see image **6.2**. From a young man to an ailing senior, Friedlander never stopped using himself as a subject, though he never set out to make himself "look good" in those portraits.

In *Shadow—New York City,* he captured his shadow as it was projected by the sunlight behind him to a nicely

This avoidance of this traditional composition gives his work a flare of modernism.

► *Google Images keywords "Lee Friedlander Shadow New York City."*

dressed woman. In his shadow, his head happens to overlap with the furry collar the woman wore, forming interesting fine radiating lines from his head, as if he was bursting with something in his mind—perhaps, curiosity? In this image, two of his favorite subjects are present—the street and women. We can certainly assume he were in a state of great excitement while photographing this. In 1979, he photographed a nude series of Madonna, who was then a struggling dancer who worked at Dunkin' Donuts.

Friedlander's shadow on the back of the woman is the dominator. Its dominance is not just because of its peculiar form and strange circumstances, it is further enhanced by being at the convergence of lines formed by the street and the buildings: the vanishing point is right at the tip of the shadow, consolidating the radiating lines of the shadow on the fur and the radiating lines of the street scenes.

Some readers might ask, how could he capture such nuances on the street, make a split-second decision, and press the shutter button at the perfect moment? I can't speak for him, but this is the quality of a great street photographer: they know a great image when they see one. What is required is a very strong, intuitive ability of composition. One can only achieve that, on top of talent, through lots and lots of hands-on practice: shoot, analyze, print, and shoot again.

Friedlander's shadow on the back of the woman is the dominator.

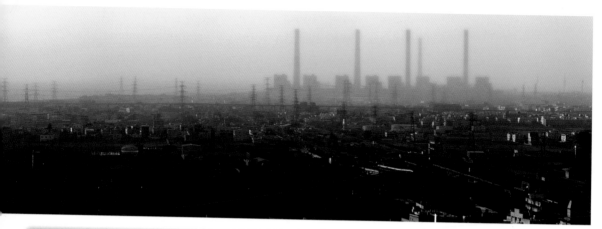

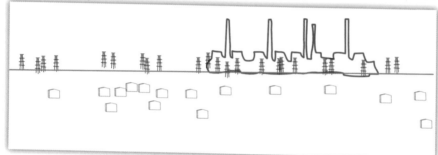

▲ image 6.3
◄ image 6.4

The next example, image **6.3**—my *6000 Megawatts*, a panorama that depicts the world's largest coal-powered plant—was created in a rather opposite process. The research about the site was conducted months ahead, a trip across the globe was made to get there, then a whole day was spent in scouting the location and photographing. The spontaneity of Lee Freidlander is replaced here with my preparedness.

The taxi driver who took me to the site told me how the residents in the neighborhood are compensated by the power plant at a rate of just $30 per month for breathing their smog—which I found suffocating, and I was only there for a few hours. As we talked about the issue, the car was cresting a hill that overlooked the town, and the gigantic silhouette of this five-smokestack facility came into view. I asked him to stop, and then I took shots to be stitched into this panorama.

The spontaneity of Lee Freidlander is replaced here with my preparedness.

Refer to image **6.4** for the composition guide. Several prominent compositional elements are at play here. The residential structures and the electric towers in the foreground have the element of repetition and variation, which emphatically underscores the vastness of this scene and therefore contextually sets up the scale of the impact. The dominator here, the power plant in its monstrous shape and scale, is towering over all the other objects in this image. This image is persuasive due to its composition.

► *Google Images keywords "David Maisel American Mine Carlin Nevada" and look for a green body of water that dominates the image.*

Analyze a Masterpiece: David Maisel

Now, let's examine David Maisel's *American Mine, Carlin, Nevada*. Maisel is known for his stunning aerial images of environmental devastation. The context of his image is horrendous, but the composition and colors are stunning. One certainly won't be blamed for claiming that his images are beautiful—they are. It is this conflict of form and context that makes his images very effective in grabbing people's attention on a very important issue.

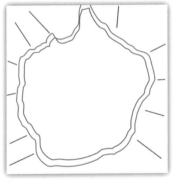

▲ image 6.5

Refer to image **6.5** for the composition guide. This image, which portrays the pollution caused by mining, features a body of water in a unnaturally striking green color that occupies 80 percent of the image. Around this green body of water there are textures on the ground that radiate from this dominator. The impact of a compositional dominator can't get any stronger than this.

The Vanishing Point

The vanishing point is the spot at which receding parallel lines converge. Image **7.1** illustrates the concept. In the illustration, the blue and green squares are the same size in the three-dimensional world. However, because the green square is farther away, it looks smaller. The four red lines are parallel, so at any given distance, an equal square can be drawn between them. As these four lines recede, the squares becomes smaller and smaller; eventually, these four lines seem to converge at a point. This point is the vanishing point.

The vanishing point is the spot at which receding parallel lines converge.

◀ image 7.1

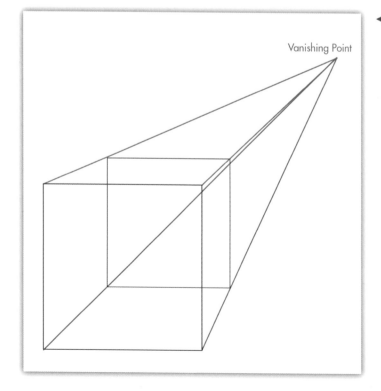

Vanishing Point

► *Google Images keywords "Bellini Procession in St. Mark's Square."*

Analyze a Masterpiece: Gentile Bellini

The vanishing point is of vital importance in paintings. Its use is essential for correctly sketching out a three-dimensional world on a two-dimensional canvas. Take Gentile Bellini's *Procession of the True Cross Before the Church of St. Mark,* for example. Refer to image **7.2** for the composition guide.

As early as the 15th century, Bellini had applied the vanishing point technique. When he painted this scene, he chose a spot on the canvas, marked it with charcoal, and drew radiating lines from it as references for the structures of the building and sizes of the human figures. In an attempt to find where that point is, I "reverse engineered" the painting by tracing the receding parallel lines. Lo and behold, where do they meet? Of course, at the altar of St. Mark!

In photography, though, the photographers are not in charge of correctly representing the three-dimensional world. We instead work the vanishing point into the composition to generate a certain feel—a sense of space, the feel of a thrust or a direction.

> As early as the 15th century, Bellini had applied the vanishing point technique.

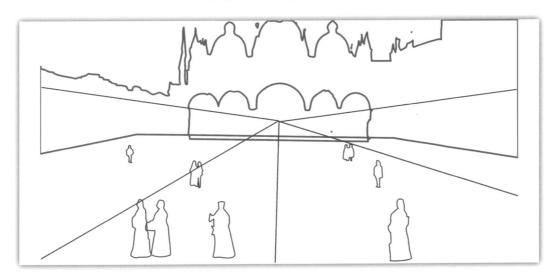

▲ image 7.2

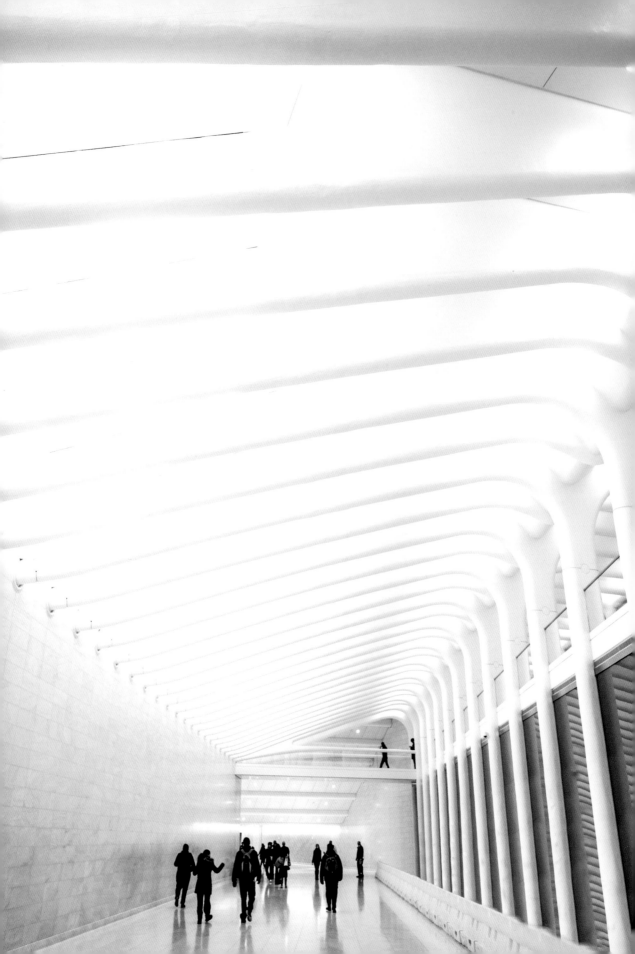

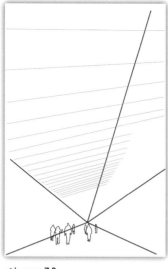

◀ image 7.3
▲ image 7.4

Image **7.3** *Terminal* is my depiction of New York's new commuter train terminal, in a science-fiction style. This minimalist architecture forcefully leads our eyes along the receding parallel lines to the vanishing point, as indicated in image **7.4**. The hard lines of the modern building are not the only element that conforms to the vanishing point, though; the sizes of the human figures also diminish along the converging lines.

After seeing these two examples, it should be evident that the vanishing point is something made up by artists. It is a compositional element that we imagined arbitrarily and defined with artificial structures and their extensions. It is not a definitive point in the space; it is where we want it to be. Starship Enterprise can fly away to any point in space at Warp 8, and that would be a vanishing point as we see it.

▶ *Enter Google Images keywords "Steichen Flatiron."*

Analyze a Masterpiece: Edward Steichen

Let's examine a few more examples in which vanishing points are used in different doses. When Edward Steichen photographed the Flatiron building of NYC in 1904, it was the tallest building in the city, thanks to the invention of the elevator. A master pictorialist, he presented the architectural feat like an impressionistic painting: there are plenty of soft lines in the trees, human figures, and misty air. The vanishing point, as illustrated in image **7.5**, is present but downplayed.

▲ image 7.5

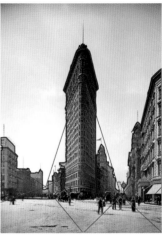

◀ image 7.6
▲ image 7.7

Image **7.6** is another portrayal of the same building. The photographer is unknown, but judging from the fashion and mode of transportation, it was likely made in the same era as Steichen's. This image's composition, though, has a unique phenomenon of dual vanishing points, thanks to the crooked direction of Broadway and the Flatiron's acute angle. See image **7.7**.

This image's composition, though, has a unique phenomenon of dual vanishing points . . .

Let's depart NYC and examine this view from Chicago's Wacker Drive. In image **7.8**, I've captured what I feel is an architectural photographer's paradise. In this scene, one can appreciate nearly a century's architecture—from the Carbon and Carbide building, second on the left, to Trump Tower at the far right.

Image **7.9** reveals a fascinating aspect of this image. Due to the usage of a super wide angle lens, there are two vanishing points: one toward the end of a street (which is the norm in all previous examples) and another at the zenith, the point to which all of the skyscrapers point. The inclusion of two vanishing points at two different dimensional axes, plus the radiating beams from the sun, make the scene appear spacious and expansive.

> Due to the usage of a super wide angle lens, there are two vanishing points . . .

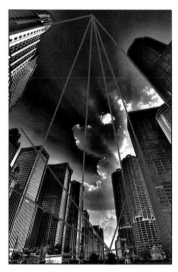

▶ image 7.8
▲ image 7.9

Stacking

A photographer's efforts to represent a three-dimensional world in a two-dimensional image are by no means a diminishing process. On the contrary, photographers often use certain compositional approaches—particularly foreground/background compositions and stacking—to assist viewers in "seeing" a third dimension.

What Is Stacking?

Stacking is evident in an image when the photographer presents subjects with similar forms along a line of sight. Because of this choice of perspective, the subjects appear to be crowding, though in the three-dimensional world this may not necessary be the case. Think about the constellations in the night sky. We see Orion as we know it (image **8.1**) not because the stars are actually arranged as such; rather, we see the alignment as we do because of our line of sight. Refer to image **8.2** for illustration. The fact that we are stuck on Earth, far from the celestial bodies, gives us no choice but to see these few stars this way.

Thankfully, we are able to see—and present to our viewers—most of our subjects in various configurations.

> Stacking is evident when the photographer presents subjects with similar forms along a line of sight.

We can change our perspective in relation to them in a way that is not possible when we look at the stars. This, as stated above, allows us to create a perception of depth in our images.

Thankfully, we are able to see – and present to our viewers – most of our subjects in various configurations.

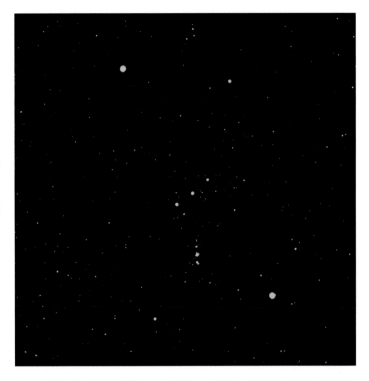

▶ image 8.1

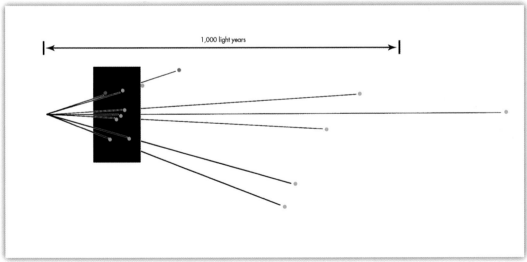

▲ image 8.2

Analyze a Masterpiece: Edward Weston

In chapter 3, we looked at some images by Edward Weston. When we view his still life images, particularly the peppers, we can see that he is a master of form. In the next image we will study, *Armco Steel Plant,* Weston used the concept of stacking to present us with compelling forms that ignite our imaginations and build a sense of depth. His skillful composition re-enforces the narrative in the image—namely, the awe that he felt toward the mighty industrial establishment. Enter Google Images keywords "Edward Weston Armco Steel Plant" and refer to image **8.3** for the composition guide.

I often observe stacks in architecture. Take Frank Ghery's Disney Hall as an example. The building is a stunning statement of postmodernism. Its iconic appearance attracts tourists, music lovers, architectural enthusiasts, and curious crowds: as a concert hall, it is certainly very functional. The building's exterior encompasses a strong stack composition, as the overall view shows (see image **8.4**). Walking around and between these facades (some of these structures are truly no more than facades), I found they form fascinating stacks. Image **8.5** shows an example of one such stack. Here, the stack underscores the missing third dimension in the two-dimensional representation.

► *Enter Google Images keywords "Edward Weston Armco Steel Plant."*

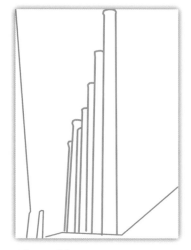

▲ image 8.3

▼ image 8.4

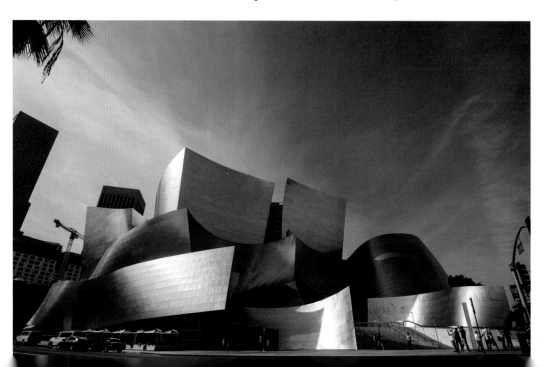

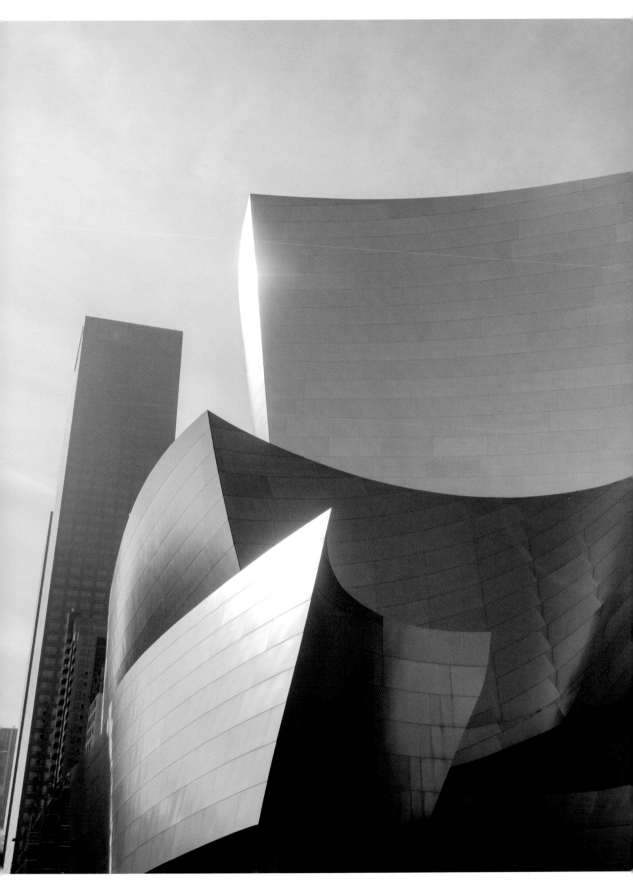

▲ image 8.5

The subjects in the stack are unified through their common curvy shapes and surface patterns, utilizing another compositional element: repetition and variation.

Analyze a Masterpiece: Walker Evans

Walker Evans and ten other photographers, including Dorothea Lange, who photographed the famous *Migrant Mother*, were hired by the Farm Security Administration to document the plight of poor farmers during the Great Depression. Evans' photograph entitled *Joe's Auto Graveyard* uses stack composition to depict the massive number of abandoned cars in a rural environment. In the background, there is only grass, trees, and the horizon. (Refer to image **8.6** for the composition guide.) The background suggests the car owners' identity: they were neither bankers on Wall Street nor middle-class workers on Main Street—they were farmers. The stacked composition of decaying cars effectively points to the scale and severity of the problem.

► *Enter Google Images keywords "Walker Evans Joe's Auto Graveyard."*

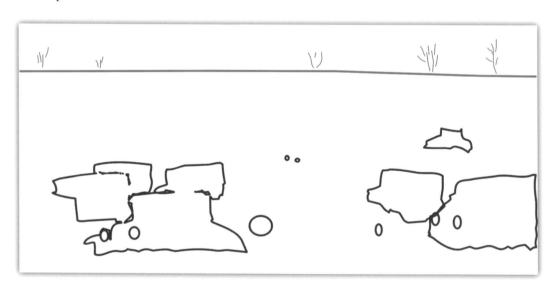

▲ image 8.6

► *Enter Google Images keywords*
"Ansel Adams UC Berkeley."

In additional to the stacking composition, Adams used repetition and variation and a foreground/background arrangement . . .

Analyze a Masterpiece: Ansel Adams

Now, let's turn our attention to a more upbeat image example. This photograph by Ansel Adams was one of over 600 prints commissioned by UC Berkeley. The collection was discovered at the library campus in 2012. To find the image, enter Google Images keywords "Ansel Adams UC Berkeley" and locate an image of University of California Berkeley's band performance in which you see sousaphones. See the composition guide in image **8.7**.

Stacking the unique shapes of these shiny brass instruments tripled the festive impression. In addition to the stacking composition, Adams used repetition and variation and a foreground/background arrangement—the band in the front and UC Berkeley's landmark, the Sather Tower (also known as the Campanile) in the back set the stage nicely. When commissioned to showcase UC Berkeley's beautiful campuses, it is a good idea to compose the image with flattery in mind.

► image 8.7

To continue with the musical theme, I would like to show you an image I produced for Trio Oriens. In this studio portrait session, it was my aim to convey a youthful flair, so I employed unconventional poses and composition. Image **8.8** is one of the shots from the session. A stacked composition was used to underscore the dynamics of the group. This resulted in size variations amongst the musicians' faces. To create a sense of balance, I positioned the musicians so that the faces were arranged with the farthest face in the center and the nearest face most off-center.

A stacked composition was used to underscore the dynamics of the group.

▼ image 8.8

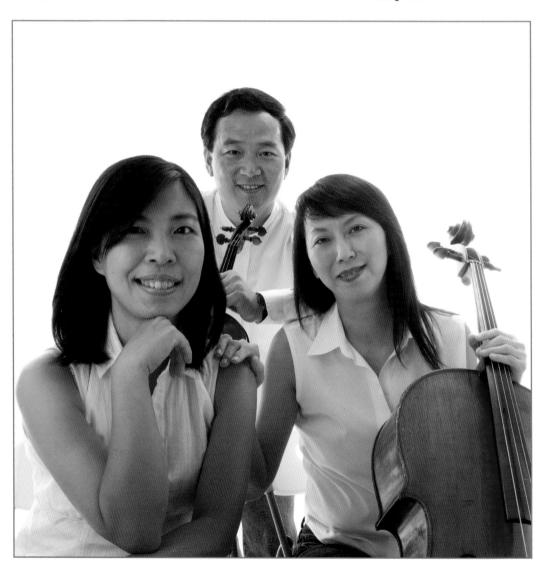

Negative Space

T he definition of negative space has to be more intuitive than scientific. When we see an image, given any medium, we can quickly form an impression of where there is something and where there is nothing. Take image **9.1**, for example. It would be the consensus' view that the water is the negative space and the boat and pier are not. But realistically, the water is not a vacuum; it is something tangible. So why would we consider it to be negative space? If a fish looked at the same boats from

▼ image 9.1

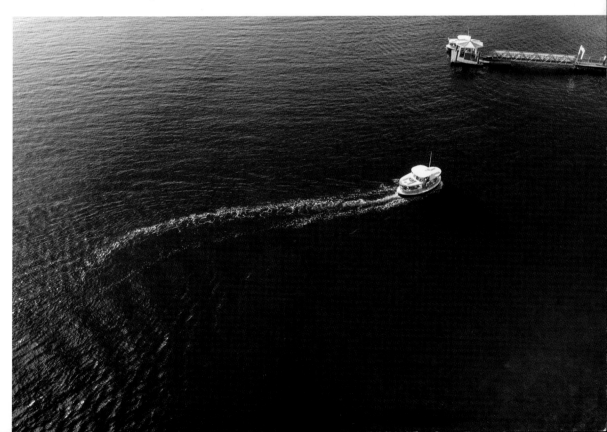

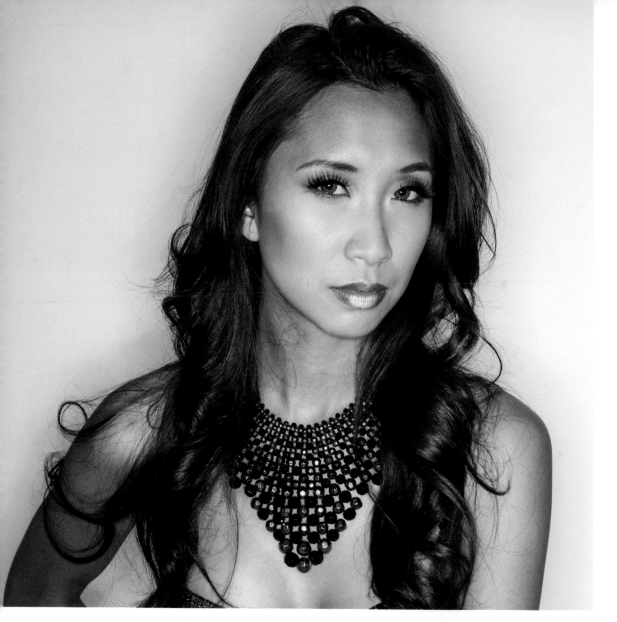

▲ image 9.2

under the water, perhaps it would consider the boat the negative space.

Now consider image **9.2**. We can easily agree that the background around the model is the negative space, and the model herself is not. What if the crop is pulled all the way to her face, so we only see some of the facial features? What would be considered negative space in image **9.3**?

▲ image 9.3

A small survey indicates a general consensus that the eye is the non-negative space and the other areas comprise the negative space.

Clearly, negative space is a contextual idea, not a formal idea.

Clearly, negative space is a contextual idea, not a formal idea. However, this idea then permeates from our contextual understanding to our formal perception. How fascinating the ways our brains work to interpret images!

So, instead of having a definition, let's base this chapter on our intuitive agreement.

▶ *Google image keywords "Francesca Woodman Polka Dots."*

Analyze a Masterpiece: Francesca Woodman

Francesca Woodman was a photographic prodigy. At the age of 13, she was already producing spellbinding self-portraits. Unfortunately, her talent was only recognized postmortem. At age 23, she violently ended her own life.

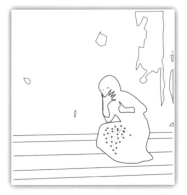

▲ image 9.4

Woodman's images are eerie, disturbing, and edging on nightmarish. They are also emotional and thought-provoking. Many of her images encompass large areas of negative space. Take *Polka Dots*, for example, and its compositional diagram, shown in image **9.4**. This is Woodman half kneeling in her favorite scene—an unkempt room with little to no furniture, peeling walls, and scattered debris. She occupies a small portion of the total area at a rule of thirds spot. We see repetitive horizontal lines. The forms are rather stable, contrary to the emotional uneasiness. The tattered walls and the debris on the floor add texture to the negative space which is, if you will, heavily loaded.

The emotion and aesthetics are dark, but the emotional aspect is caused by an interesting blend of forms and contexts. The negative space in the room creates a sense of

vulnerability: there is no place to hide. The grungy surfaces make viewers cringe: we don't want to touch them. Her pose furthers the discomfort: she is in an awkward position and is partially exposed. All these elements combine to make this image iconic. Look through the Google Images results and you will find a consistent style amongst Woodman's compositions.

Negative space can be the coincidental star when the perspective sets the stage right. Image **9.5** is an example of that. This straight-up view of skyscrapers in downtown Los Angeles is a composition without a horizon. A composition of this type inherently decreases stability and lends a dynamic feel to the image. To counterbalance, the vanishing point, led by the receding parallel lines of the buildings, acts as an anchor from which the skyscrapers seem to hang. The streetlight adds interest by the inversion

A composition of this type inherently decreases stability and lends a dynamic feel to the image.

▼ image 9.5

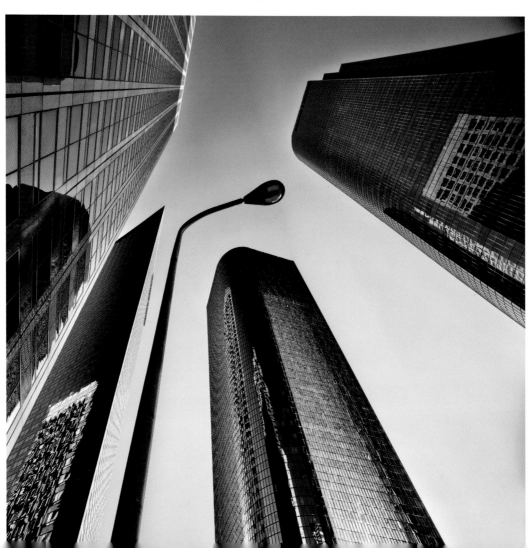

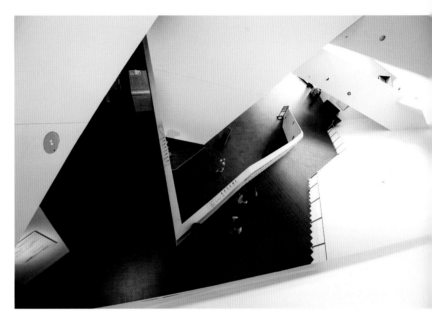

▲ image 9.11

▲ image 9.12

their context. One can argue that, compared to Western paintings, these views are more inward and spiritual.

In both graphic design and painting, negative space is thoughtfully created. It's less often seen in photographs. Therefore, when the opportunity arises to harness its power, I won't miss it. Image 9.10 was photographed inside of the Denver Art Museum. This postmodern architectural masterpiece by Daniel Libeskind is fun to visit and to photograph. First, the piece is without vanishing points: the lack of parallel lines provides no convergence. Refer to image 9.11 for the compositional analysis. Second, viewers are presented with the confusion of negative space. Look at image 9.10 and ask: what is the negative space here? Is it the black floor or the white wall? Refer to image 9.12, which is the original image with in high contrast to emphasize the black floors and white walls. This confusion leads us to see things we normally do not see: the geometrical shapes of the floor and the wall both claim territories that attract equal attention from us. The notion of negative or positive is voided.

Framing

P ut a photographer in a surrounding and give her the assignment to depict that environment. The first question she has to ask herself is "Where should I point the lens?"

Lots of things go through the mind of the photographer who is charged with a mission to be the eyes of the viewers. She observes the light and identifies interesting forms, shapes, and narratives. If there is action involved, she waits for a moment for it to reveal itself, then she clicks the shutter to capture the images based on a split-second thought processes. At these moments, she has decided what the viewers should see.

. . . framing can be used to further concentrate the viewer's attention.

Analyze a Masterpiece: W. Eugene Smith

A compositional element called framing can be used to further concentrate the viewer's attention. In framing, a physical form is used to shape a margin around the main focal point. This margin, normally a negative space, directs the viewer's gaze to the center stage. Let's take W. Eugene Smith's *Walk to the Paradise Garden* as an example. Refer to image **10.1** for the composition guide.

▶ *Enter Google Images keywords "W. Eugene Smith Walk to the Paradise Garden."*

The great war photographer was injured on the battleground. He was recovering at home, not making any images for a couple years. Then one day, he took a stroll with his two children, Juanita and Patrick. A magical moment presented itself. In his own words:

"While I followed my children into the undergrowth and the group of taller trees—how they were delighted at every little discovery!—and observed them, I suddenly realized that at this moment, in spite of everything, in spite of all the wars and all I had gone through that day, I wanted to sing a sonnet to life and to the courage to go on living it….

"Pat saw something in the clearing, he grasped Juanita by the hand and they hurried forward. I dropped a little farther behind the engrossed

I wanted to sing a sonnet to life and to the courage to go on living it….

children, then stopped. Painfully I struggled—
almost into panic—with the mechanical iniquities
of the camera....

"I tried to, and ignore [*sic*] the sudden violence
of pain that real effort shot again and again
through my hand, up my hand, and into my spine
... swallowing, sucking, gagging, trying to pull
the ugly tasting serum inside, into my mouth
and throat, and away from dripping down on the
camera....

I knew the photograph, though not perfect, and
however unimportant to the world, had been held
[*sic*] I was aware that mentally, spiritually, even
physically, I had taken a first good stride away from
those past two wasted and stifled years."

And such a masterpiece it was to mark the end of his
"stifled years!" This is arguably the bible of framing. The
frame, shaped by the shadowy side of the plants and the
trail, is beautiful in form and informative in context. The
kids' figures were backlit, leaving most of their backs dark
but outlinging their contours with a glow. The garden
area they were facing was well lit and slightly overexposed,
leading the pair's imaginary line of movement. Formal
elements and contextual elements can't harmonize any
better than this.

I found it interesting to compare *Walk to the Paradise
Garden* with my *Warmhole of Central Park* (see image
10.2 and image **10.3**, the composition guide), which also
incorporates a strong framing element. The lighting has a
similar setup: backlight came from the end of a "tunnel,"
leaving the framing in the shadow. Both photos have two
human figures, but the former is gentle and soft and they
walk into the highlight, and the latter is harsh and alien
and they walk into the shadow. The two works are formally

The kids' figures were backlit, leaving most of their backside dark but sketching their contour with a glow.

similar but contextually opposite. I swear I did not realize this similarity until I was writing this book, though.

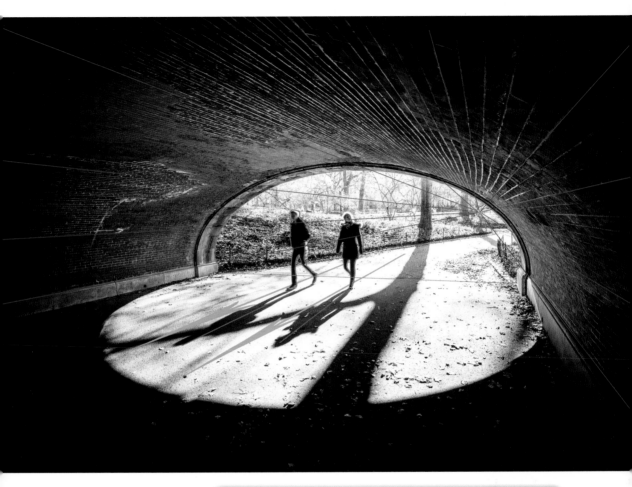

▲ image 10.2
▶ image 10.3

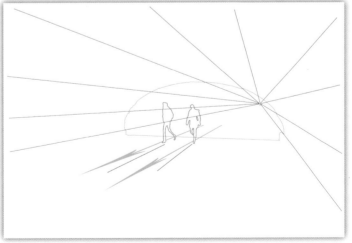

Brooklyn Bridge was built over 130 years ago. Today, its engineering feat still amazes. Whereas the bridge has never changed, Brooklyn has gone through a transition from an industrial town to today's new hip neighborhood. The place where I stood to take the photo (image **10.4**) was an industrial ruin. Observing Brooklyn Bridge's tower through a window of the ruin not only frames the intricate structure, provides a foreground/background contrast and

▼ image 10.4

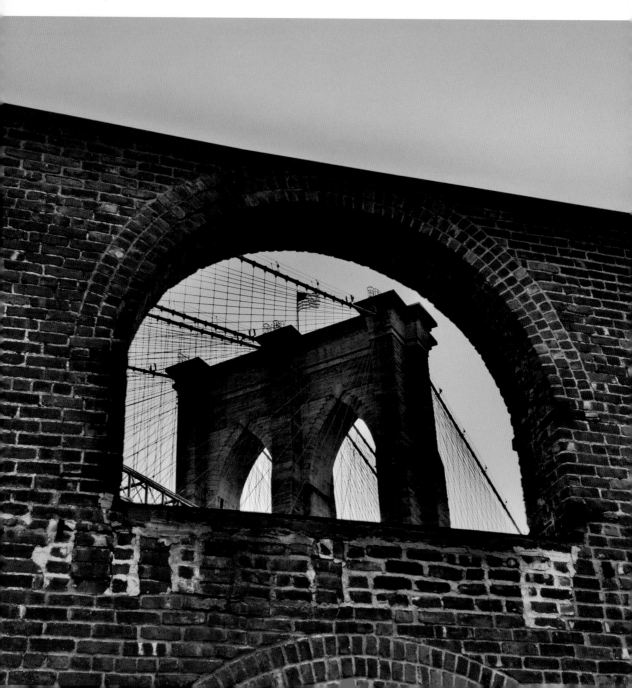

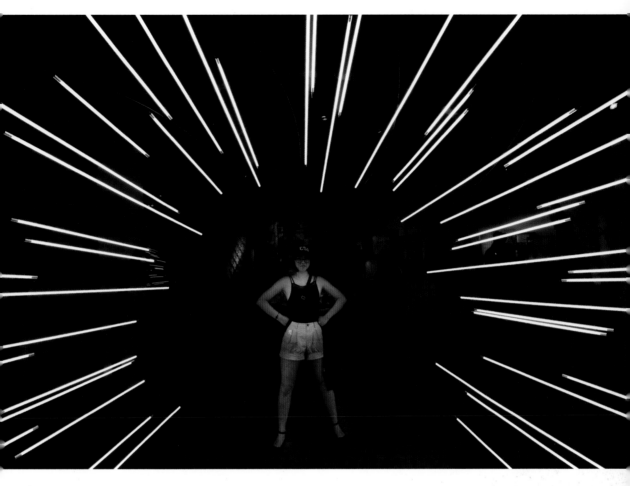

▲ image 10.5

harmonizes through the repetition and variation of the brick patterns on the wall and the bridge, it also provides a historic context to the bridge.

Image **10.5** shows a less anticipated kind of framing. This museum display at Experience the Music Project, Seattle, makes an interesting tunnel of light beams. Besides serving the purpose of framing the human figure, it has also the element of repetition and variation and radiating lines. With the human figure located at the center of the radiation, all attention is focused on her.

With the human figure located at the center of the radiation, all attention is focused on her.

A sight like image **10.6** with planets framed in modern architecture is not something we see everyday, though it exists at the Hayden Planetarium at Natural History Museum, NYC. The realistic planetary models, besides being reined in by the framing of the building, are also in juxtaposition with it. On the structure of the housing, we can see the rhythmic repetition and variation and a stabilizing triangular shape.

▼ image 10.6

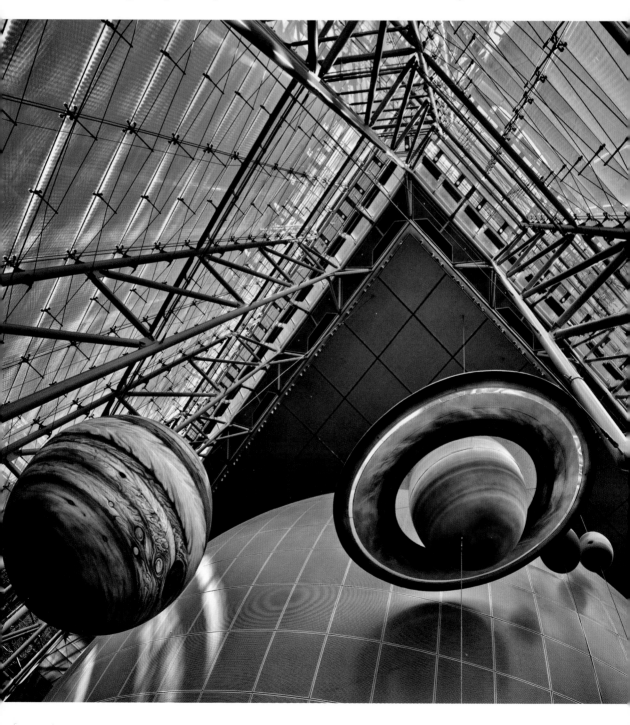

▶ Enter Google Images keywords "Henri Cartier-Bresson Children Playing in Ruin."

Analyze a Masterpiece: Henri Cartier-Bresson

Masters like Ansel Adams or Edward Weston were extraordinary at the art of composition. Of course, they were able to take their time when composing an image, as landscapes and still life subjects do not rush. Henri Cartier-Bresson, a street photographer, did not have that luxury. He had to work quickly, so we should especially appreciate the masterful framing in his *Children Playing in Ruin*. This photo was taken in Seville, but the date is in dispute. Some records indicate this was taken in 1933, but some argued this was after the Spanish Civil War. The context suggests a war-torn community, but we can't be certain.

Refer to image **10.7** for the composition guide. Like W. Eugene Smith's *Walk to Paradise Garden*, the framing in *Children Playing in Ruin* is a masterful touch both formally and contextually. A hole on a broken building has such power to rein in the viewer's attention: it is minimalistic, it has very interesting repetition and variation. The figures of the children, juxtaposed to the ruin, present a rendition of repetition and variation.

The framing in *Children Playing in Ruin* is a masterful touch both formally and contextually.

▲ image 10.7

The Rule of Thirds

The many compositional elements covered in this book have their roots. Some of them have references dated back to the Renaissance; some of them are summaries from my practices, and some of them are commonly recognized "rules"—though we do want to underscore the one nature of rules: they are made to be broken. In the world of art, there really are no rules. But, for the purposes of conforming to the widely accepted term, we will settle for the title "the rule of thirds" for this chapter.

▲ image 11.1

In the world of photographic education, if there is one compositional element to be mentioned, it is the rule of thirds. Image **11.1** illustrates how it is defined. Divide the long and short edges of an image into three equal segments, and draw two horizontal lines and two vertical lines through those points. Once you have done this, you will see that the lines intersect at four points, which we will call rule of thirds points (they are sometimes referred to as power points). These points are well suited for placing focal points. A dominator would feel at home at a rule of thirds point or along any of the vertical or horizontal thirds lines.

The lines intersect at four points, which we will call rule of thirds points.

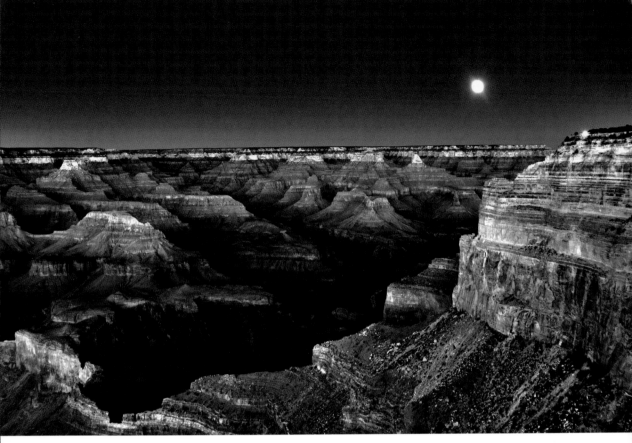

▲ image 11.2
▶ image 11.3

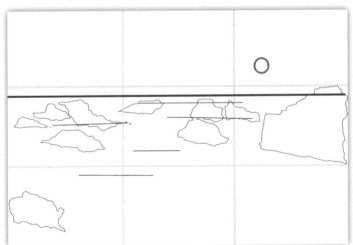

I applied the rule of thirds in *Moonrise at Grand Canyon* (image **11.2** and image **11.3**) to determine the ideal placement for the moon. This made it the prominent celestial feature in contrast to a massive terrestrial canyon. A masterpiece by Mother Nature, Grand Canyon naturally

encompasses many compositional elements. In this image, you can see a prominent horizon and many horizontal lines, repetition and variation, and texture.

Analyze a Masterpiece: Ansel Adams

When it comes to the composition of landscapes, all standards were set by the great master Ansel Adams. Not all his landscapes use the rule of thirds, but there are a few successful images that do. Yosemite was one of his favorite locations. At Tunnel View, a vantage point where one can see the grandest view of Yosemite Valley, he photographed the panorama many times, under different seasons, light, and weather conditions. My favorite one is a winter scene.

► *Enter Google Image keywords "Ansel Adams Tunnel View" and look for an image of a scene with snow coverage and clouds.*

Refer to image **11.4** for the composition guide. The two red circles denote El Capitan (on the left) and Ribbon Falls (on the right). In this panorama, there are also other compositional elements at work: the trees provide repetition and variation and the surface of the rocks, forest, and clouds add texture.

▲ image 11.4

As you might have noticed, in the examples we have reviewed so far, the objects do not fall precisely on the rule of thirds points. That's fine. I once had a student from a high school who, upon hearing about the rule of thirds, exclaimed that their school's photo contest judges checked for precision adherence to the rule with a ruler. If you ever see this happening among the jurors, please buy a copy of this book give to them as gift, with a bookmark placed right on this page. Photography is not engineering, and a ruler is not needed to evaluate images.

Let's look at a few examples from my own photo archive. I need to confess that the rule of thirds was not on my mind

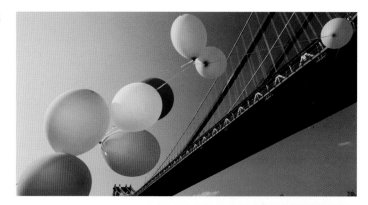

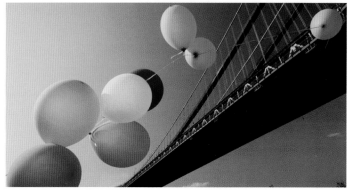

when I captured them. Clearly, in the split seconds when I pointed my camera at these scenes, some photographic gravity pulled my arms so the subject of interest fell to a rule of third spot. The rule of thirds just *works*.

Image **11.5** was captured under the Manhattan Bridge just as a bunch of escaping balloons were about to soar. The balloons are situated at the left-lower rule of thirds point and the bridge appears at the lower-right rule of thirds point. Both subjects have an equal visual pull. Note that the balloons and the bridge create parallel diagonal lines, and the receding parallel lines of the bridge suggest a vanishing point outside of the frame. These elements add a dynamic feel to the composition. The only horizontal and vertical lines are on the tower at the far end of the bridge. Though the tower is small, the lines stabilize the composition. For the sake of experiment, I cloned it out in image **11.6**. Without the tower, the image seems to tilt over.

Though the tower is small, the lines help stabilize the composition.

Image **11.7** is a sight that you don't see everyday. In fact, if you have not seen it, you never will: this is a view of the old and new Bay Bridge, taken in San Francisco in November 2013. When I captured the shot, the new bridge was operational and the old bridge was soon to be torn down, its steel beams sold.

Refer to image **11.8** for the composition guide. The two bridges converge to a vanishing point. The radiating lines make the image dynamic. The kid-towing bicyclist is positioned at the lower-right rule of thirds point. Its prominence adds liveliness to the image: the new bridge is carrying us!

▼ image 11.7
▶ image 11.8

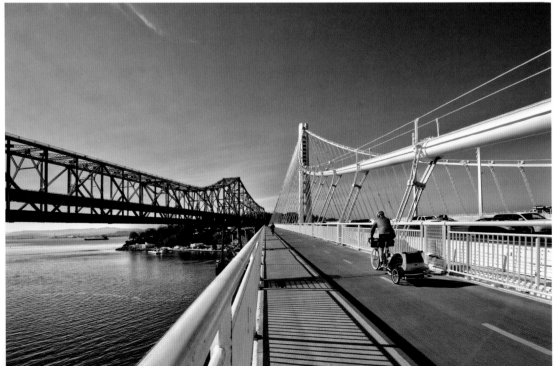

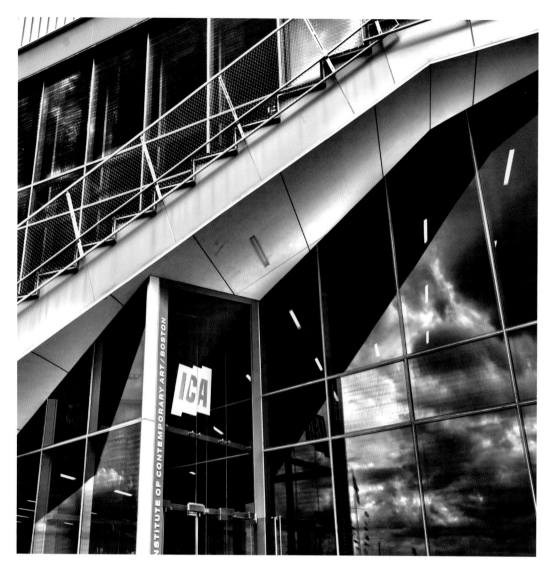

▲ image 11.9
▲ image 11.10

Boston's Institute of Contemporary Art (ICA) is a wonderful museum to visit. It features wonderful collections, of course, but its architecture is a work of art in its own right (see image **11.9**). Like some other modern buildings, ICA has a lot of hard lines that sketch out complex geometrical shapes in three dimensions. As illustrated in image **11.10**, the complexity can be overwhelming. First, there are the features—the stairway and door. Then there are the frames on the glassy surface, which form receding parallel lines that project to a

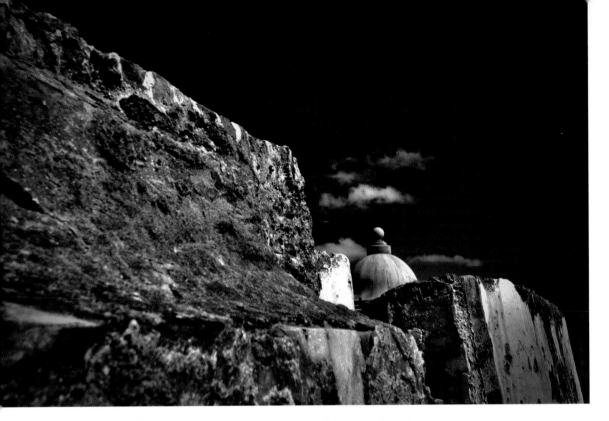

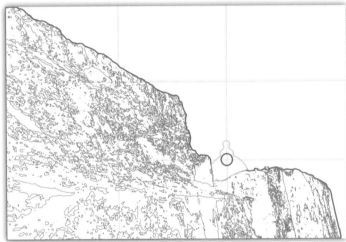

Presenting the image in black & white reduces the complex visual details to a series of forms.

vanishing point out of the frame. Inside the windows, we see the light on the ceiling, which also converges to a vanishing point. These details are of interest because they are fun and intricate and hold the viewer's attention. At the same time, however, they create chaos in the image. Presenting the image in black & white reduces the complex visual details to a series of forms and reins in some

of the chaos. Placing the museum's logo on a rule of thirds point is another solution. In this position, the logo anchors the image, creating a focal point that the eyes can return to for a rest when they tire of traversing the intricate lines.

El Morro, the beachhead fort in Old San Juan, Puerto Rico, has been my favorite place to visit (image **11.11**; see also image **11.12** for the composition guide). The natural decay of the walls is not good news for preservationists, but for photographers, it produces a texture that we can almost feel with our eyes. The texture in the foreground provides a juxtaposition for the very smooth tip of a sentry booth in the background. On top of these compositional elements; placing it in a rule of thirds point, tops it off with the undivided attention from the viewers.

> The texture in the foreground provides a juxtaposition to the very smooth tip of a sentry booth . . .

The rule of thirds interacts with other compositional elements in each of the photographs in this chapter. Sometimes they join forces and sometimes they counterbalance one another.

▶ *Enter Google Images keywords "Cate Blanchett Annie Leibovitz Bike."*

Analyze a Masterpiece: Annie Leibovitz

Finally, let's look at a fun image by Annie Leibovitz. Her images of celebrities are as famous as the celebrities she portrays. Most of her recent pieces are staged in highly sophisticated productions. This image of Cate Blanchett on a bike, though, is simple and candid. Image **11.13** shows the composition guide. As the shoot was staged at an airfield, Cate Blanchett's speeding down the runway seems to suggest her imminent takeoff. This impression is enhanced by the parallel lines on the runway and the imaginary line of her movement. To keep her balanced, the triangular shape creates a good, bottom-heavy impression. Finally, placing her at a rule of thirds spot puts the actress in the limelight, as she deserves.

▲ image 11.13

Repetition and Variation

Repetition is abundant in music. A theory to explain our fondness for repetition is that it instills a sense of security. A tune becomes a friend. When it shows up for the second or third time, we are happy to be reunited. With the variations, each time, we discover something new and different. There is a sense of refreshment and surprise.

Take the Beatles' *Here Comes the Sun,* for example. You can listen to the song on YouTube and read the lyrics too. Just go to https://www.youtube.com/watch?v=BxzEeKfpyIg. When the page loads, pull the playing mark to 1:30, where the "sun, sun, sun, here it comes" section starts. The same musical phrase is repeated six times. The first time it is purely instrumental. The second time, the vocal parts join in. The third time, bass chords are added on the left channel. The accumulation of layers continues through the sixth repetition. This is the true essence of musical repetition and variation.

> This is the true essence of musical repetition and variation.

Analyze a Masterpiece: Wassily Kandinsky

The same aesthetics exist in visual art. Take Kandinsky's abstract paintings, for example. According to the artist:

▶ *Enter Google Images keywords "Wassily Kandinsky Composition 8."*

"Colour is the keyboard, the eyes are the hammers, the soul is the piano with many strings. The artist is the hand which plays, touching one key or another, to cause vibrations in the soul." Kandinsky certainly agreed with this interchangeability between the two media. Let's look at his *Composition 8*. Try to count the number of circles, semicircles, and polygons. They repeat a lot, yet they vary in color, size, texture, sharpness, and the size of the outlines. The viewer can hear music! Lots of Kandinsky's abstracts are explosions of repetition and variation.

The repetition and variation of the turbines dominates the image; any other objects are minimized.

Renewable energy is one of my favorite photographic subjects. Wind power requires a great number of turbines, each one with an average of 3 megawatts output, to generate significant energy. A massive wind farm in Abilene, Texas, can be best depicted through repetition and variation. This strategy was used in image **12.1**. The repetition and variation of the turbines dominate the image; any other objects are minimized. The very low horizon and distant trees provide a simple stage and pose no competition for attention.

A 1:3 ratio panorama is a natural choice for portraying the broad scope of a wind farm in one image. The vertical

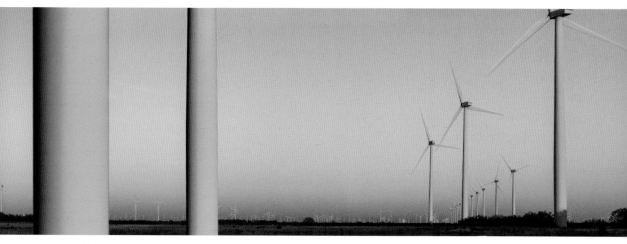

▲ image 12.1

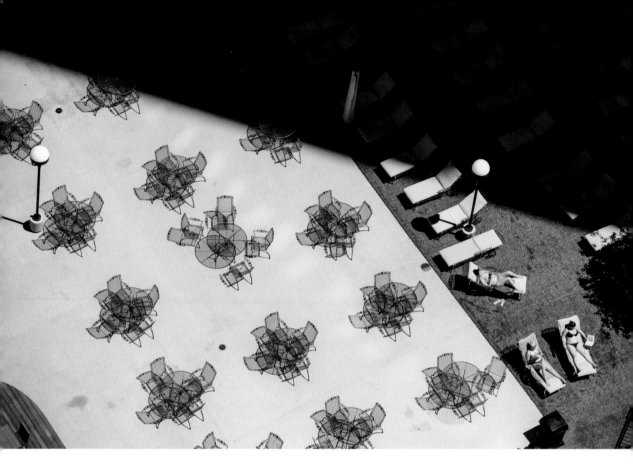

▲ image 12.2

lines from the columns of the turbines provide a sense of upward thrust, which is much needed on a wide and short print. In a panoramic composition, it is possible to create "localities"—areas within the frame that feature varying compositional approaches. For instance, in this example, the left side features strong open composition elements; two foreground turbines show only part of their columns, whereas the other parts of the image show close composition.

After wind energy, shall we examine solar power? My Chicagoan friends have to soak in as much solar energy as possible in the summer. While on my friend's balcony one summer, I saw the fun scene depicted in image **12.2**. It manifests itself as a perfect composition. The repetition and variation are present in the chairs and tables and also in the lounge chairs. The division between the cement

The repetition and variation are present in the chairs and tables and also in the lounge chairs.

and lawn forms a diagonal line, and the shadow joins in, crisscrossing the divide, creating four combinations of surfaces and adding another variation. The sunbathers relaxed at a rule of thirds point. What more could I ask for?

► Enter Google Images keywords "Chris Jordan Intolerable Beauty."

The edges of the massive piles do not appear in the images; therefore, we have open compositions.

Analyze a Masterpiece: Chris Jordan

Chris Jordan, a photographer who concerns himself with the environmental impact from our mass consumption, is the king of repetition and variation. In his book *Intolerable Beauty: Portraits of American Mass Consumption* (self-published, 2005), he shows photographs of junk produced by us in staggering quantity. I will not be using composition guides here, as the element of repetition and variation is easily conveyed in the original photographs.

There is no need to narrow your search down to any specific image in this series. The overview of the images the search result will call up is a beautiful example of repetition and variation! Click on any of the images and you will see a sea of cell phones, cigarette butts, junked cars, bullet casings, plastic bottles, etc. The edges of the massive piles do not appear in the images; therefore, we have open compositions. Our imagination is engaged and we ask ourselves, with horror, Where is the end of all of these?

All these images are presented in wall-size prints. When the viewer steps in close, the individual objects emerge. When the viewer steps back, repetition and variation dominate the perception. When he or she steps back even farther, the massive repetitions and variations become a texture.

Distance and Field of View

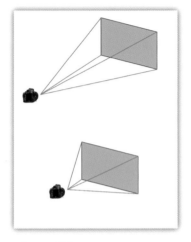

▲ image 13.1

In chapter 5, we explored the role that the foreground and background play in suggesting a three-dimensional scene on two-dimensional media. The compositional element is not exclusively for photography. There are plenty of foreground/background usages in paintings. Distance and field of view, though, are rather exclusive to photography because they reflect an optical phenomenon that is hard to emulate in paintings.

Image **13.1** explains field of view. In a nutshell, the field of view is the angle formed between the lens and the edges of the scene (or view) that the lens covers. When a telephoto lens is used, the field of view is more narrow than when a wide-angle lens is used. This is because a telephoto lens "sees" a narrower area of a scene than does a wide-angle lens.

The field of view has a tremendous impact on our compositions. Let's examine image **13.2**. Suppose we take a photograph of a flower in front of a tree with a wide-angle lens and a telephoto lens (to achieve a wide field of view and a more narrow field of view, respectively) and ensure that the flower is rendered the same size in

▲ image 13.2

▲ image 13.3

each image. Naturally, using a wide angle lens will require taking the shot from a very close distance, and taking it with a telephoto lens will require shooting from a much longer distance. In the image captured with the wide-angle lens, the camera would be so close to the flower that it would appear much larger in comparison to the tree. In the image made with the telephoto lens, the size relationship between the flower and the tree would appear much closer to their real sizes.

This distortion in scale is actually due to the ratio in distance. Imagine taking a third shot at the far point, using the wide angle lens, as illustrated in image **13.3**. Naturally, using such a wide field of view from this distance will result in a small tree and very small flower. Lo and behold: when the image is cropped in to the flower, there will be an image with exactly the same scale ratio as shown in image 13.2, shot with the telephoto lens. What this teaches us is that distance determines scale and field of view determines the crop.

Distance determines scale and field of view determines the crop.

Analyze a Masterpiece: Ansel Adams

Take a look at Ansel Adams' *Mount Williamson, Sierra Nevada*. Many compositional elements are equally dominant in the image. (See image **13.4** for the composition guide.) The high horizon line sets our focal point mostly on the terrestrial features, while dividing the foreground and background with two distinctive textures. The repetition and variation on the rocks provide a rhythm. This rhythm is loud in the foreground and fades as the rocks recede to smaller sizes, facilitated by distance and field of view.

► *Enter Google Images keywords "Ansel Adams Mount Williamson Sierra Nevada."*

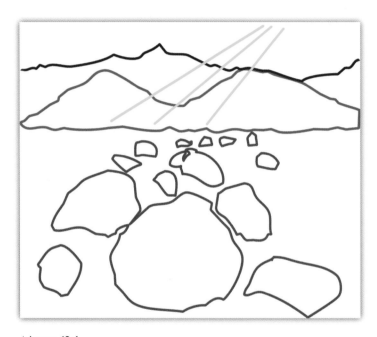

▲ image 13.4

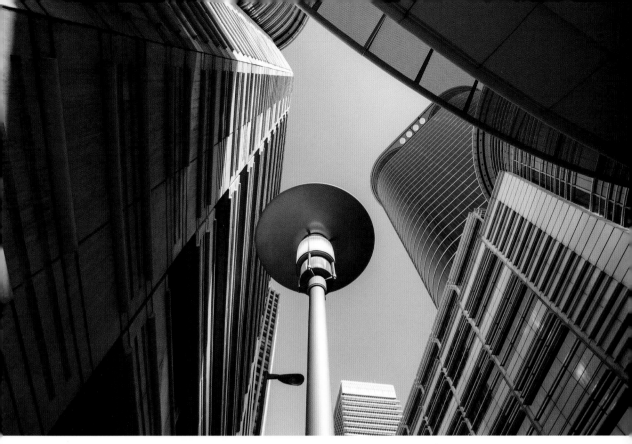

▲ image 13.5
► image 13.6

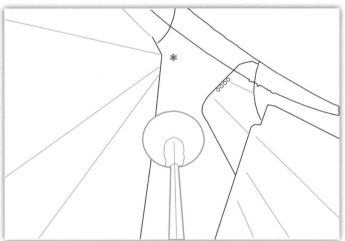

My depiction of Houston as a modern city (image **13.5**) was photographed from a sidewalk with a stunning architectural maze. Refer to image **13.6** for the composition guide. The many textures, lines, and curves raise the level of chaos, which is then reined in by other unifying elements. Repetition and variation is abundant,

▲ image 13.7

including a surprising congruence between the circular shape of the lamp and the decorative feature at the top of the building. The lamp post serves as a stabilizing dominator, and the vanishing point where the receding parallel lines meet serves as a stabilizer for the other element, the architectural feature. To bring the fun to a higher level, distance and field of view make the smallest object—the lamp post—the most dominant object. It's the unlikely star of the show.

Image **13.7** presents an interesting variation on distance and field of view because the up-close object is mirror-like. The subject of the image is a public art piece in Chicago; technically, it is called *Cloud Gate,* but it is intimately referred to as *The Bean* by the locals. Image **13.8** shows a more typical view of the surrounding—which,

Distance and field of view make the smallest object – the lamp post – the most dominant object.

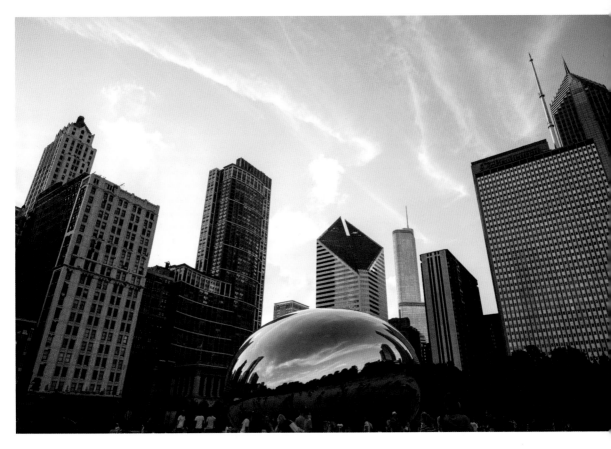

▲ image 13.8

interestingly, was photographed while viewing the artwork 180 degrees from where image **13.7** was taken. Check out the buildings in both shots and you will find the mirror image reflects the reality. No Photoshop here!

The juxtaposition of a city skyline and a mysterious spheric mirror is a very strong compositional element. It makes the image an enigma. This focal point is enhanced by the radiating lines of the cloud, shooting away from the sphere. The texture caused by the imperfection of the mirrored surface provides some contextual clues (that this is a mirror) and lends formal interest. These elements were made possible by distance and field of view when the camera was set very close to *The Bean*, making it so enormous it seems to have enveloped Chicago.

> This focal point is enhanced by the radiating lines of the cloud, shooting away from the sphere.

▲ image 13.9

Do not assume the fun only exists when a wide field of view is employed. Image **13.9** was photographed with a very narrow 5 degree field of view on a 500mm lens. The wind turbines were miles away from where I stood, so the several-hundred-foot distance between them became rather insignificant. Because of this, the turbines look very crowded, much more so than they actually are.

The vertical and radiating lines from each turbine, all at different angles, provide a strong sense of repetition and variation. Nothing can be more effective than this to depict the sheer number of turbines required to produce substantial energy.

The selfie, a 21st century photographic phenomenon, might not strike us as mainstream in the art world.

The lines from each turbine, all at different angles, provide a strong sense of repetition and variation.

However, there are some things to be said about it. It enjoys an enormous popularity anywhere in the world where cell phone use is prevalent. While I won't analyze its social impact, I will analyze its compositional impact.

Selfies are taken mostly at arm's length, so the distance is short and the field of view is wide. This provides interesting aesthetics. Take my friend Sharone Goe's selfie (image **13.10**), for example. The short distance between the face and the lens creates a distortion that highlights the subject's facial features—particularly her eyes. Also, because the image is a self-portrait, the photographer is guaranteed to capture the decisive moment. Have you ever seen a selfie in which the subject's eyes were closed?

> Selfies are taken mostly at arm's length, so the distance is near and the field of view is wide.

▶ image 13.10

Sharone added a masterful touch to her selfie when she framed the image to ensure the leaves between herself and the camera would serve as a foreground. The leaves, her face, and the foliage behind her establish a great sense of depth, facilitated by distance and field of view.

Analyze a Masterpiece: Lee Friedlander

The selfie was not an invention of the cell-phone-toting generation. Lee Friedlander captured a series of self-portraits as early as the 1960s. He did some of them in exactly the "standard" selfie pose: he held his camera at arm's length and pointed the lens at his face. His self-portrait on the street of New York was photographed this way. Refer to image **13.11** for the composition guide. Friedlander's interest in women, especially when they are shopping, is evident in many of his pieces. In this image, a female figure carrying shopping bags is positioned at a rule of thirds point, counterbalancing the artist's out-of-focus face and menacing expression, which comprise roughly half of the image. I suspect this image is a reflection of what was going on in Friedlander's mind.

► *Enter Google Images keywords "Lee Friedlander Self-Portrait New York 1963" and look for his big, out-of-focus face.*

I suspect this image is a reflection of what was going on in Friedlander's mind.

▲ image 13.11

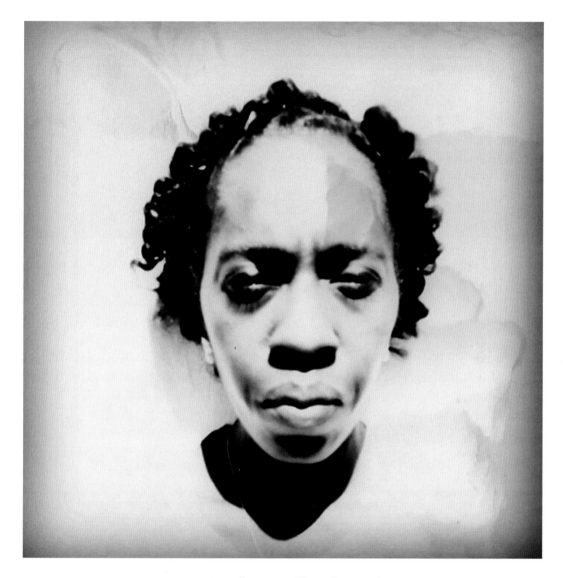

▲ image 13.12

To fill large-format film with a face, he has to put the camera a few inches from the subjects.

My colleague Jeff Bradley produces stunning portraits with a pinhole camera that he built himself. Image **13.12** is one of his pieces. To fill large-format film with a face, he has to put the camera a few inches from the subjects. This creates a strong sense of scale distortion. This fact, combined with the blurriness caused by the subject's movement in an exposure that lasts for several minutes, creates a surreal effect. Bradley's pinhole camera seems to be able to venture closer to the inner space of the subject, through the closeness and the essence of time.

Texture

I n earlier days, all of the physical characteristics of the objects in our photos were represented on photographic paper. In the digital era, computer monitors and projections do the same. To convincingly depict the physical world on these smooth media, texture is essential.

Take image **14.1**, my image of an industrial ruin, as an example. This panorama was captured inside of an old

▼ image 14.1

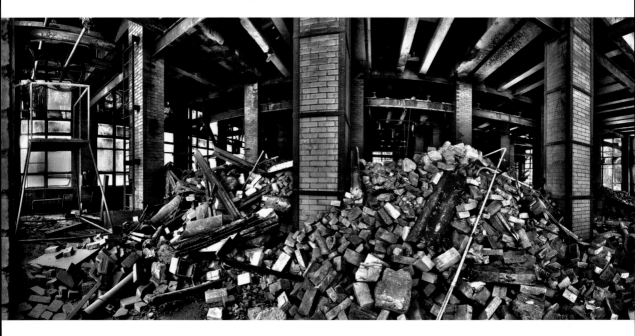

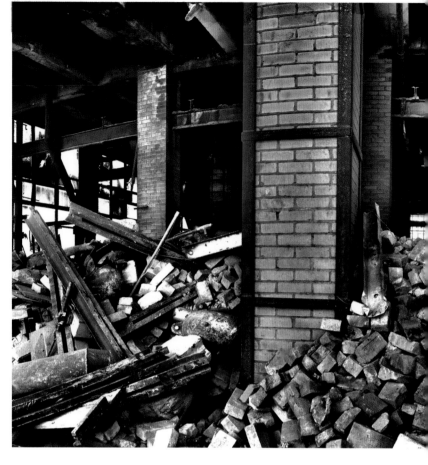

The texture was enhanced with high dynamic range imaging. It is the most dominant and unifying compositional element.

factory that was ready to be demolished. I used a 1:3 format to showcase the scale and severity of the chaos. The interior space fits nicely into this format, resulting in a framing that helps to contain the chaos, limiting it in a closed composition.

The texture was enhanced with high dynamic range imaging (for more information, read my book *Professional HDR Photography* [Amherst Media, 2013]). It is the most dominant and unifying compositional element. See image **14.2** for a detailed view that reveals the texture. This "grunge" texture on the bricks, the wall, and the pipelines unifies them and makes them a "team." It also creates a visceral reaction in us: we might not like to touch them.

Analyze a Masterpiece: Francesca Woodman

Francesca Woodman is a master of depicting uneasy feelings. To gain a general understanding of her aesthetic and subject matter, enter Google Images keywords "Francesca Woodman." The meaning behind this talented young photographer's work is still a mystery. What is evident is a sense of disturbance. Take her image *Self-Deceit #1*, for example. Refer to image **14.3** for the composition guide. This self-portrait shows her nude figure crawling in a reptilian way into a room with nothing but a mirror, reflecting her image while she examines herself intently. Like many of her self-portraits (some of the portraits she photographed that look like self-portraits were actually modeled by a doppelganger with whom she collaborated), the settings often have elements that cause discomfort: broken glass, blood, and snakes, to name a few. In this simple setting, the contrast between her smooth skin, rough wall, and sharp edge of the mirror creates tension. "Someone might get hurt" is the visceral feeling it imparts to viewers. Tragically, this narrative foreshadows her suicide.

▶ *Enter Google Images keywords "Francesca Woodman Self-Deceit #1."*

The contrast between her smooth skin, rough wall, and sharp edge of the mirror creates tension.

◀ image 14.3

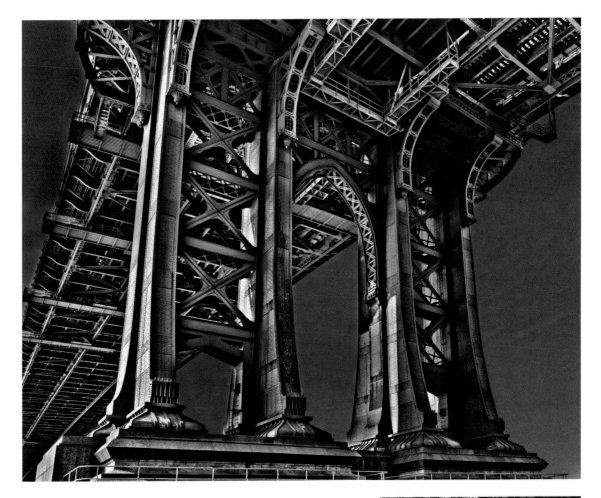

▲ image 14.4
▶ image 14.5

In image **14.4**, the subject is the Manhattan Bridge—a champion of texture. The all-steel structure has millions of rivets, curves and arches, and decorative features; it is an architectural gem of a bygone era. No bridges will ever be built like this again.

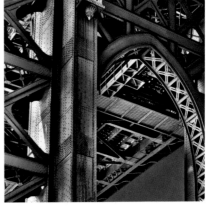

To depict this structure with a sense of time, the peeling paint and rust have to be prominently showcased.

To depict this structure with a sense of time, the peeling paint and rust have to be prominently showcased. Image **14.5** is a close-up view that shows the fine details. With the textures, this image witnesses history: the photograph

◀ (top) image 14.6
◀ (bottom) image 14.7

itself becomes unique for our age: decades before and decades later, the Manhattan Bridge will not look the same.

While I captured the man-made texture with hard lines, my colleague Lauren Lohman depicted something natural and fluid in image **14.6**—the sea. Refer to image **14.7** for the composition guide. The open composition transforms the seascape into an abstract. The waves form receding parallel lines that extend to converge at a vanishing point outside of the image, creating a sense of vastness. The compositional element in the limelight is the texture of the choppy waves. These small ripples form a rhythmic pattern that repeats but is never the same. This image of the sea is minimalistic yet complex.

The open composition transforms the seascape into an abstract.

There are times when texture becomes the sole interest in an image. Image **14.8** and image **14.9** are a diptych from my *Congruence* series, a study of nature's similar forms in very different scales. This pair is a scene of a snow-covered Alaskan Rocky Mountain and a slice of New York strip steak. The striking similarity between the two was the highlight of our trip in Alaska when a few foodie friends "saw" the steak in the mountain.

These conflicting visual cues makes such a comparison interesting.

An open composition is rather necessary to constrain the viewer's gaze to only the textures in an image. It is rather interesting that while the form of the snowy mountain and the steak are congruent, their colors are not. These conflicting visual cues makes such a comparison interesting.

▼ (top) image 14.8
▼ (bottom) image 14.9

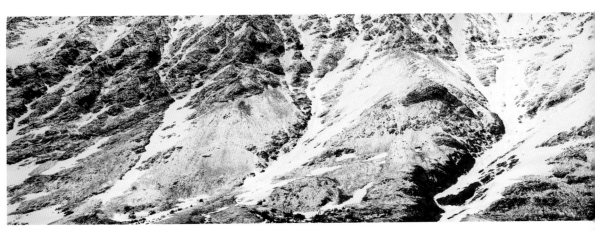

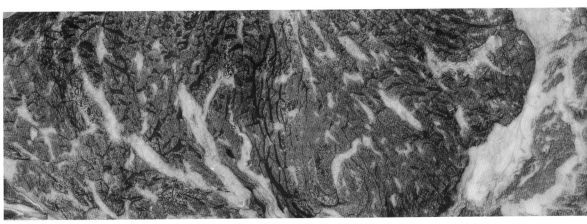

Analyze a Masterpiece: Lalla Essaydi

A contemporary master whose work has a strong textural presence is Lalla Essaydi. I have not included a composition guide, as the intricate texture in her work can't be conveyed this way. Her work incorporates photography and Arabic calligraphy. This fusion of the two media permeates the levels of form, context, and concept. Conceptually, this is her rebellion against the treatment of women, particularly their inaccessibility to the sacred form of calligraphy. Contextually, these images have a strong enough cultural origin to pique the curiosity of viewers from all cultural backgrounds. Formally, these images are stunning, and they have a very different appeal at differing viewing distances. Up close, they reveal female forms and intricate calligraphic strokes. From a distance, the details transform into textures. Essaydi's work is delightful on many different levels.

► *Enter Google Images keywords "Lalla Essaydi."*

This fusion of the two media permeate into the levels of form, context, and concept.

Controlled Chaos

L ife is not simple. Complexity is all around us. When we walk around an urban neighborhood, we see crisscrossing power lines, commercial signs of different sizes and colors, buildings made of different materials, and cars in various shapes. Our surroundings are chaotic. The chaos poses challenges for us photographers who are photographing in such environments.

▼ image 15.1

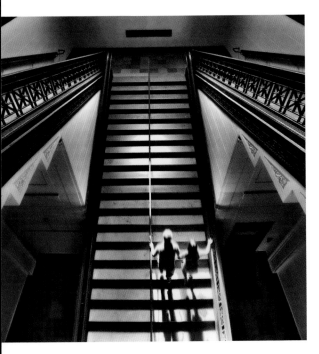

There are two methods to rein in the chaos. Method one is to point the lens away from it. Method two is to encompass the chaos in the image, then control it with the unifying power of compositional elements. If chaos itself is the narrative, obviously method one is out of the question. So the question is, how do we portray chaos without a chaotic composition?

Let's take my *Inescapable Mathematics* (image **15.1**) as an example. Taken in Fort Worth, Texas, it portrays a pair of commercial buildings' intertwining lines,

repetitive reflections, and a network of metallic frames. The complexity of this image is overwhelming: the close-up view of the building fills up the whole frame, overflowing the crop to form an open composition. Its metallic frames crisscross, thanks to its architectural design of many intersecting surfaces. In the center of the images, the V-shaped lights in the stairway shine through the windows, forming another theme of repetition and variation. On the right side, the reflection of the twin building is in full view. There is a closed composition contrasting with the open composition of the first building, and it is aesthetically and informatively interesting.

The chaos—clearly the narrative here is meant to portray the sophistication of an urban and commercial world—is reined in with two compositional elements. As mentioned above, the first element is the repetition and variation. A few objects are repetitive here: the metallic frames and the windows within and the clouds. All of them are omnipresent in the whole image, and all of them are so varied that no two units are identical. Direct your attention to these elements, one at a time, and you will start to see the image as being much more orderly.

The second element is the subdued color. The image is monochromatic with a persisting hue of blue/cyan. The simplicity of color prevents any of the objects from monopolizing the attention; instead, the numerous objects now seem to wear uniforms.

With the application of these compositional elements, the chaos is under control.

Let's look at three more examples of controlled chaos in urban scenes. These are pieces by my friend Angie McMonigal, a Chicago-based architectural photographer

> The lack of color prevents any of the objects from monopolizing the attention.

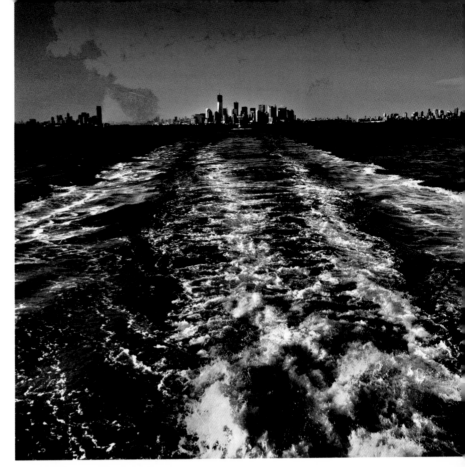

▶ image 15.2

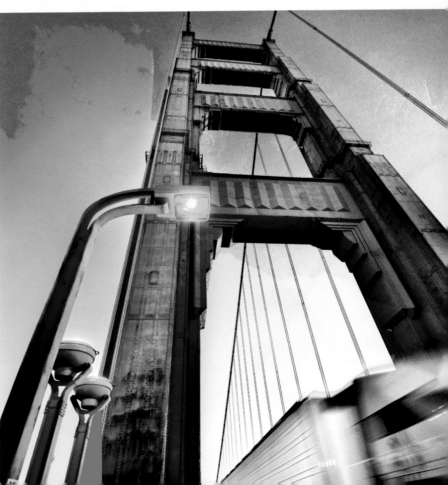

▶ image 15.3

whose images never cease to amaze me with delicate details and pulsating rhythms. Images **15.2**, **15.3**, and **15.4** are from her *From the L* series. The L, short for "elevated," is an over 100-year-old mass transit system in the center of Chicago, and voted by Chicagoans one of the seven wonders of Chicago. The routes of the L cut through the densest part of Chicago where new and old buildings coexist, railroads crisscross, and signage explodes. How does she rein in the chaos?

In image **15.2**, a junction of the railroad tracks is situated amongst the high-rise buildings of various eras and architectural styles. This is as chaotic as it can be. In McMonigal's compositions, she uses the massive railroad track, which is rather monochromatic, as the dominator. On this visual focus, the planks repeat and provide repetition and variation. These two elements rein in the chaos, making sure the viewers' attention does not wander aimlessly. On top of this well-laid ground, a

These two elements rein in the chaos, making sure the viewers' attention does not wander aimlessly.

▼ image 15.4

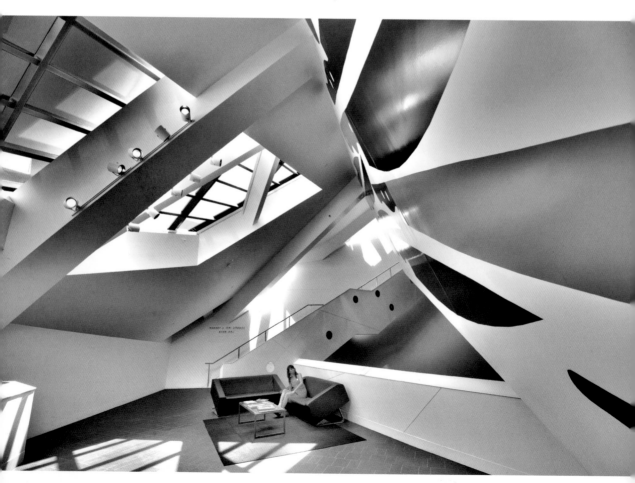

strong vanishing point from the converging railroad tracks coincides with the incoming train, which sits perfectly on a rule of thirds point. These compositional elements are masterfully incorporated to bring order to chaos.

In image **15.3**, an equally chaotic scene is seen through the window of the moving train. In here, the movement of the train makes most of the objects blurry except the other train in the distance, which clearly was moving in the same direction at a similar speed. The motion blur reduced the texture, turning detailed structures into a larger area of colors and simplifying them. Therefore, the compositional element used to reduce chaos is applied in a "negative dose": by reducing texture, chaos is under control. The distant train that stays sharp becomes the dominator that sits on the rule of thirds point. Once again, a few elements join forces to counter the chaotic scene.

> The dominating compositional element in image 15.4 is framing; it is the major force that keeps chaos in check.

The dominating compositional element in image **15.4** is framing; it is the major force that keeps chaos in check. This framing not only creates a formal container for the chaotic scene, it also sets a contextual framework about the train: "I am looking at a train from a train" is the first impression. The shapes of these framing elements form a repetition and variation between themselves and the windows of the other train, further connect this and that train, and makes us wonder if there is a passenger aboard the other train, looking back at us.

▶ *Enter Google Images keywords "Gregory Crewdson," then search for a large image so that you can examine these images closely.*

Analyze a Masterpiece: Gregory Crewdson

Gregory Crewdson (born in 1962) is an American photographer who depicts small-town lives through tableaux—a storytelling photo with stationary figures set in a wide-angled scene of streets or the interior of a home. At first glance, these images seem banal and calm, but a

closer look reveals disturbing undertones of depression, isolation, corruption, violence, etc. Enter Google Images keywords "Gregory Crewdson," then search for a large image so that you can examine these images closely.

It is worth mentioning that Crewdson's images often encompass many objects, which results in a high level of complexity. To make sure the scene does not become chaotic, every still object, every human figure, is carefully placed, angled, and distanced, and then the scene is delicately lit to highlight the drama. In a way, Crewdson is more like a movie director than a photographer. The control of chaos in his process is the production of the scene itself: while most of us move the camera around to compose, he moves objects around to compose.

▲ image 15.5

Image **15.5**, *Power Plant,* is one of my images. It depicts the complexity of the machinery used to generate electricity. The extremely complex network of pipelines is the narrative and the aesthetic. So how is the chaos reined in?

First of all, the monochromatic nature of the plant reduces chaos with a uniform color. Second, in this complex composition of lines, there are a few dominating ones that stand out to enforce order. Please refer to image **15.6**. The two blue lines denote the two stairs, which set themselves apart by being the only prominent slanted lines and by being brighter. Now look at the three shiny objects that look like tanks, marked with orange in the diagram. Finally, note the large number of vertical lines. These three line elements form repetition and variation, unifying the chaos.

The monochromatic nature of the plant reduces chaos with a uniform color.

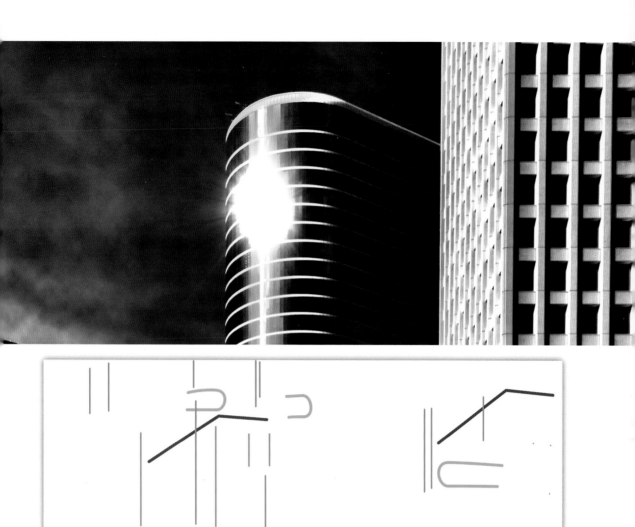

▲ image 15.6

Aspect Ratio

The photograph's ratio of width and height is the topic of this chapter. This topic, though seemingly simple, has a profound impact on a photograph's composition.

The History

Let's start with a bit of historic perspective. The 4:3 ratio is arguably the father of all aspect ratios. William Kennedy Dickson, while working for Thomas Edison, chose this ratio for their kinetoscope. This ratio stuck with us when the motion pictures chose to inherit it. However, the ratio had little connection to the development of still photography until Oskar Barnack developed the first small camera, the "Ur-Leica," using the 35mm film for movie productions. When the movies were shot on the film, the long side (the "4" in the 4:3) was used for the width of the film. Oskar Barnack doubled the movie's frames for the still photo's frames, therefore doubling the "3" in the 4:3. Thereby, the ratio became 4:6 or, simplified, 2:3.

Over a hundred year later, we are still affected by Oskar Barnack's design: today's DSLRs make use of the 2:3 ratio.

> The 4:3 ratio is arguably the father of all aspect ratios.

Large format: 8"x10"

Large format: 4"x5"

Square format on 120 film: 56x56mm

35mm film and FX sensor: 24x36mm

DX format seonsor: 16x24mm

▲ image 16.1

The era of HDTV introduced another popular ratio: 16:9. The 16:9 ratio is a compromise between the narrowest and widest movie format, so when reformation is necessary to fit a movie to the TV screen (remember the note "This movie has been formatted to fit your screen" at the beginning of a VHS?), a minimum of cropping is required.

The Cameras

SLRs and full-frame DSLRs (FX) shoot a frame in a 2:3 ratio, whose measurement is 24x36mm. The cropped-sensor DSLRs (DX) have sensors that measure 16x24mm. They also have a 2:3 ratio. However, in the film era, medium format cameras were used with 120 film and mostly produced square images measuring 56x56mm. Large format cameras used either 4x5 or 8x10 sheet film.

SLRs and full-frame DSLRs shoot a frame in a 2:3 ratio, whose measurement is 24x36mm.

Both camera types produced images with a 4:5 ratio. Image **16.1** (page 115) illustrates the comparison of these film sizes.

The Photo Papers

Another practical consideration is the aspect ratio of photo papers. In the days when photo enthusiasts visited one-hour photo labs, the most often printed image size was 4x5. A crop on the long side of the camera's 2:3 image is necessary. Here is a question for the readers who are old enough to have visited a one-hour photo lab: Were you ever asked how you'd like your photos cropped? The answer, for me, is no! Most one-hour lab technicians cropped the photos at their discretion.

To print everything on 4x6 papers would solve the problem, as the ratio coincides with the camera's 2:3 format. But when it comes to printing on 8x10 stock, the crop issue arises again, and the long side of 2:3 images must be cut.

This seemingly benign topic can't be neglected when prints are your main method of presentation. One might choose to print on any paper with arbitrary ratios, then trim the excessive borders. But this is not always doable as some prints are not easily cut (e.g., prints on metal). Unusual ratios also complicate framing when standard mats and frames don't have matching aspect ratios.

This seemingly benign topic can't be neglected when prints are your main method of presentation.

Image **16.2** illustrates the standard sizes of the photo papers.

Monitors and Projectors

When it comes to monitors and projectors, we concern ourselves with the number or pixels instead of measurement of inches because each device has a different density of pixels. Before the HD era arrived, 1024x768 was the standard resolution of computer monitors and projectors. The HD ratio of 16:9 reshaped some monitors.

Apple's 27-inch Thunderbolt display, for example, boasts a resolution of 2560x1440 (a ratio of 16:9).

Today's projectors show images with varying aspect ratios: XGAs have a resolution of 1024x768, WXGAs have a resolution of 1280x800, and HDs have a resolution of 1920x1080.

Image **16.3** illustrates the various formats of projected images.

Now that we have taken care of the practicalities, we can learn how aspect ratios impact composition.

► image 16.2

16"x20" and 16"x22"

8"x10" and 8"x12"

4"x5" and 4"x6"

► image 16.3

Apple Retina Display 2800x1800

Apple 27" Thunderbolt Display 2560x1440 (16:9)

HD TV, HD projector, dSLR Video, most video cameras 1920x1080 (16:9)

1024x768

Square vs. Elongated

Let's consider the width and height, two balancing forces in the photograph they frame. The width possesses the stabilizing force and the height possesses the uplifting force. A square image clearly balances these two. Let's look at a few examples. Images **16.4**, **16.5**, and **16.6** each

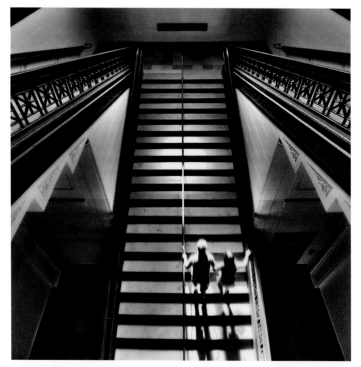

◀ image 16.4

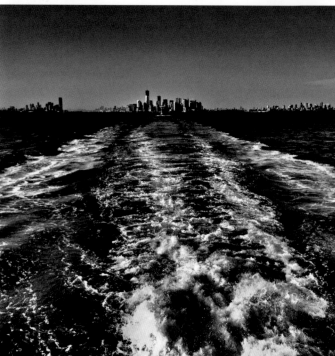

◀ image 16.5

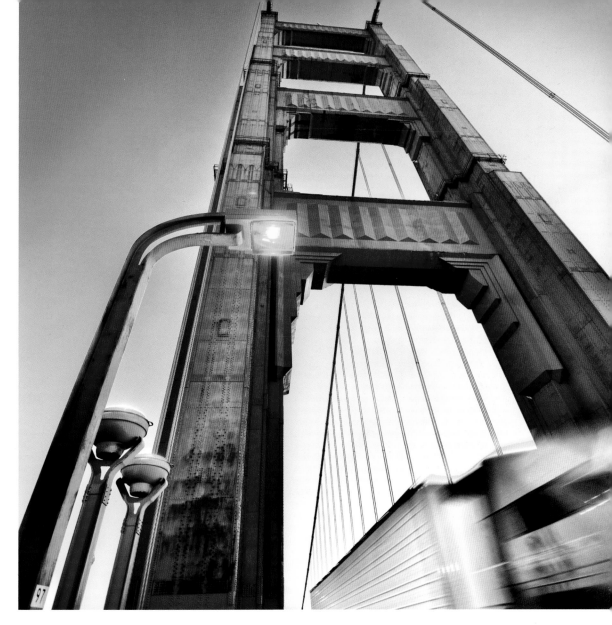

▲ image 16.6 feature a particularly strong compositional element: in image **16.4**, it's the vanishing point; in image **16.5**, it is the high horizon, and in image **16.6**, it is the vertical line and vanishing point. Because they are all framed in squares, the effects of the horizon and vertical line are moderated: we don't feel a particularly strong presence of these compositional elements. The vanishing points in image 16.4 and image 16.6 still feel prominent, though.

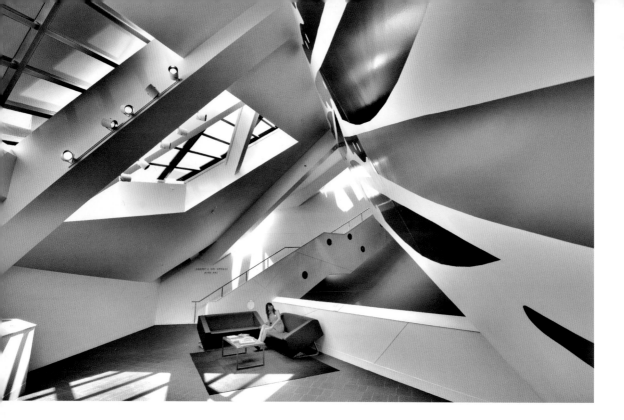

▲ image 16.7
▶ image 16.8

Now let's observe a few images with a 2:3 ratio, the native aspect ratio of DSLRs. Now that the height and width are different, there is an option to use the long side as the height (i.e., portrait format) or as width (i.e., landscape format). Image **16.7** shows the interior of the Denver Art Museum, where a visitor can find few horizontal or vertical lines—except the floor, that is. The image captures the architectural style, but the sense of up and down doesn't feel very confused. We can thank the orientation provided by the stairway and the small human figure, but the credit should also go to the landscape orientation of the 2:3 aspect ratio, which stabilizes the chaos of lines. Image **16.8**, on the other hand, is a case study of a portrait orientation supporting a composition with dominating vertical lines. Because they joined forces, the upward thrust of the skyscrapers look strengthened.

There is a conventional wisdom that 2:3 is too narrow to be presented in portrait orientation. If you ever read about

The image captures the architectural style, but the sense of up and down doesn't feel very confused.

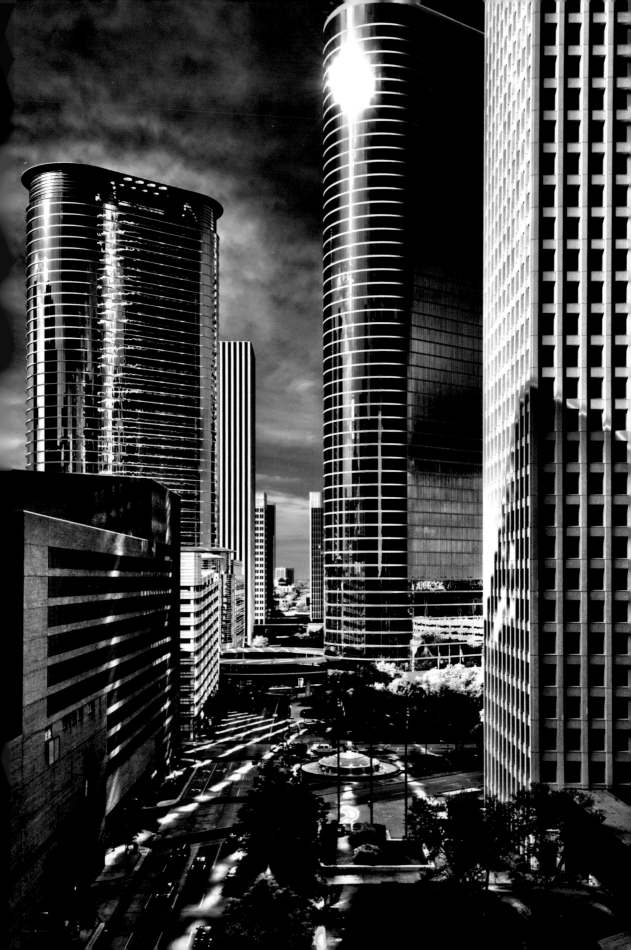

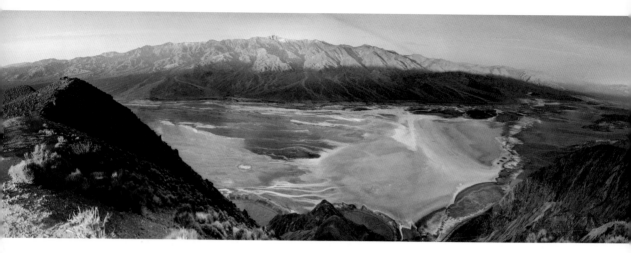

▲ image 16.9

that notion, please dismiss it. Art does not blossom under moderation. On the contrary, true innovations in art are often found by probing the extremes. The attempts might fail, but in many cases they become major breakthroughs.

On the notion of extremes, let's look at the very elongated formats. I shall call these the panoramas—no matter if they are presented in landscape or even portrait format (yes, the latter is completely presentable). I will also define panoramas at aspect ratios that are more elongated than 1:3.

Image **16.9** is a 1:3 aspect ratio aerial view of Death Valley, with the salt-laden dry riverbed in the foreground and Telescope Peak in the background. This scene is, by nature, panoramic: a visitor standing where I stood would naturally scan this awe-inspiring wonder of nature from left to right. Once again, the expansive horizon joins force with the horizontal panoramic aspect ratio, making this photograph a faithful depiction of the grandeur I witnessed.

The expansive horizon joins force with the horizontal panoramic aspect ratio . . .

Some of nature's wonders do not share this orientation. Take the hoodoo of Bryce Canyon in image **16.10**, for example. To emulate the eye movement of an eyewitness, I turned the 1:3 panoramic to a vertical orientation. The

dominating vertical line now teams up with the aspect ratio. The high horizon near the top, combined with the extreme vertical elongation, creates a unique impression of gazing deep into the earth, which is not too far from the physical truth.

How would this unusual format work in reality? Image **16.11** shows this photo hung in the dining room of a collector. It works perfectly for both the composition and the display.

How would this unusual format work in reality?

► image 16.10
▼ image 16.11

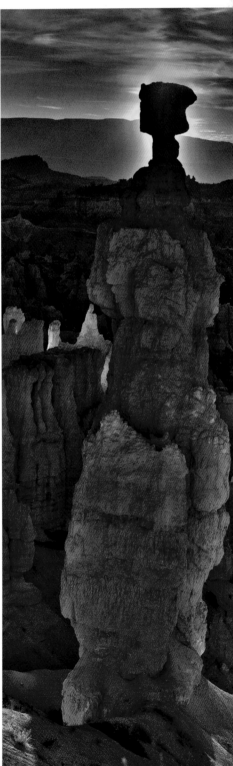

Tightness of a Composition

Review the images in this chapter and think about how "tight" a composition is. The square ratio, equally cropping width and height, fences in the composition most effectively. The more elongated the format is, the more "loose" the composition becomes, as the viewers' eyes are giving varying degrees of freedom. Compare images **16.12** and **16.13** to better understand this point.

What impact does this bring to the composition? It turns out that a compositional element might be strengthened or weakened by a certain aspect ratio. Any compositional element that is sensitive to the position of objects is strongest in a square format. These include open/closed compositions, the rule of thirds, and framing.

▲ image 16.12

The compositional elements that are independent from the position of the object emerge as more dominant in elongated ratios. They include line, repetition and variation, texture, and controlled chaos.

▲ image 16.13

Image **16.14** is a panoramic view of a seaport in northern Taiwan. Controlled chaos and repetition and variation have a strong presence here. But, if we consider the positioning of the two nearer ships, located at a rule of thirds point, we would conclude the effect is not prominent.

Given these considerations, and based on the freedom of eye movement, it is only natural that print sizes come to mind. Square ratios work well when prints are smaller than 10x10 inches, as restricted eye movement can enhance the tight composition. Panoramas, on the other hand, are not well suited to small print sizes. The viewer's eyes have to be set free to roam about the print. Consider, again, image 16.14. The long side can't be more than 10 inches in this book; therefore, readers are not presented with an optimal viewing experience. My presentation of this print is 60 inches on the long side. The texture, lines, and repetition and variation stand out nicely in the large presentation.

Square ratios work well when prints are smaller than 10x10 inches . . .

▼ image 16.14

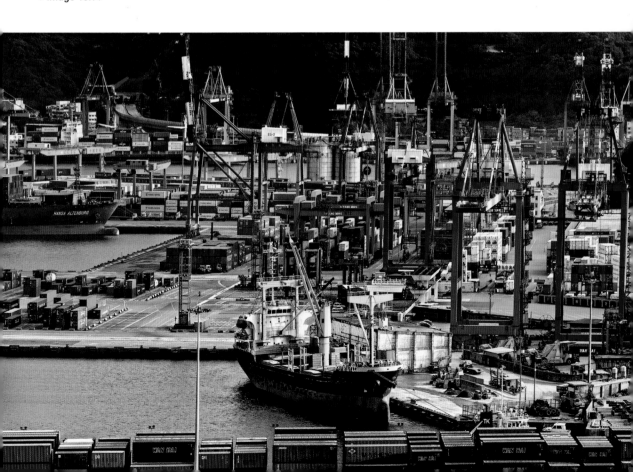

Index

Storytelling for Photojournalists

Enzo dal Verme (*Vanity Fair*, *l'Uomo Vogue*, and more) shows you how to create compelling narratives with images. *$37.95 list, 7x10, 128p, 200 color images, index, order no. 2084.*

After the Camera

Thom Rouse creates artwork that begins with nude and portrait photos, then spirals out into other worlds through creative postproduction compositing. *$37.95 list, 7x10, 128p, 220 color images, index, order no. 2085.*

Shot in the Dark

Brett Florens tackles low light photography, showing you how to create amazing portrait and wedding images in challenging conditions. *$37.95 list, 7x10, 128p, 180 color images, index, order no. 2086.*

Cheap Tricks

Chris Grey shares inventive lighting solutions and techniques that yield outstanding, creative portraits—without breaking the bank! *$37.95 list, 7x10, 128p, 206 color images, index, order no. 2087.*

Mastering Light

Curley Marshall presents some of his favorite images and explores the classic lighting approaches he used to make them more expressive. *$37.95 list, 7x10, 128p, 180 color images, index, order no. 2088.*

Senior Style

Tim Schooler is well-known for his fashion-forward senior portraits. In this book, he walks you through his approach to lighting, posing, and more. *$37.95 list, 7.5x10, 128p, 220 color images, index, order no. 2089.*

The Complete Guide to Bird Photography

Jeffrey Rich shows you how to choose gear, get close, and capture the perfect moment. A must for bird lovers! *$37.95 list, 7x10, 128p, 294 color images, index, order no. 2090.*

Relationship Portraits

Tim Walden shows you how he infuses his black & white portraits with narrative and emotion, for breath-taking results that will stand the test of time. *$37.95 list, 7x10, 128p, 180 color images, index, order no. 2091.*

Smart Phone Microstock

Mark Chen walks you through the process of making money with images from your cell phone—from shooting marketable work to getting started selling. *$37.95 list, 7x10, 128p, 180 color images, index, order no. 2092.*

Sikh Weddings

Gurm Sohal is your expert guide to photographing this growing sector of the wedding market. With these skills, you'll shoot with confidence! *$37.95 list, 7x10, 128p, 180 color images, index, order no. 2093.*